LOST
COLUMBIA

LOST
COLUMBIA

BYGONE IMAGES FROM
SOUTH CAROLINA'S CAPITAL

ALEXIA JONES HELSLEY

THE
History
PRESS

Published by The History Press
Charleston, SC 29403
www.historypress.net

Copyright © 2008 by Alexia Jones Helsley
All rights reserved

First published 2008
Second printing 2011
Third printing 2013

Manufactured in the United States

ISBN 978.1.59629.532.2

Library of Congress Cataloging-in-Publication Data

Helsley, Alexia Jones.
Lost Columbia : bygone images from South Carolina's capital / Alexia Jones Helsley.
p. cm.
Includes bibliographical references and index.
ISBN 978-1-59629-532-2 (alk. paper)
1. Columbia (S.C.)--History--Pictorial works. 2. Historic buildings--South Carolina--Columbia--Pictorial
works. 3. Historic sites--South Carolina--Columbia--Pictorial works. 4. Neighborhood--South Carolina--
Columbia--History--Pictorial works. 5. Columbia (S.C.)--Buildings, structures, etc.--Pictorial works. I. Title.
F279.C7H38 2008
975.7'71--dc22
2008037983

Dedicated to Bill and Sharon Messer and Eleanor Katherine Wells
who have the gift of encouragement,
and in memory of
Charles Edward Lee (1917–2008),
archivist, historian and preservationist

CONTENTS

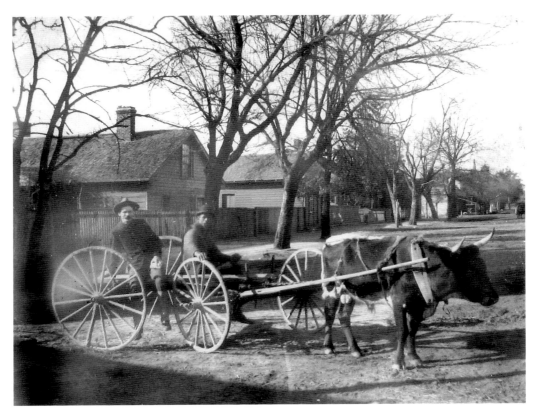

"A South Carolina Horseless Carriage," circa 1899. Ox carts were a popular, inexpensive form of transportation. Tolls for ox carts were generally cheaper than for horse-drawn carriages and wagons. The 1872 South Carolina dollar featured a wagon drawn by two oxen on its obverse. *Photograph by Harry M. King (photograph 12050.8). Courtesy of South Caroliniana Library, University of South Carolina, Columbia.*

PREFACE

I moved to Columbia in 1967 to attend graduate school at the University of South Carolina. By 1968, I was working for the South Carolina Department of Archives and History, then located at the corner of Senate and Bull Streets. My first taste of "lost Columbia" was the disappearing neighborhoods around the university. Organisms must grow or die and in many ways, Columbia is fortunate to have retained a sense of its history and preserved the houses and buildings that reflect different eras in the city's development. Yet natural and man-made destruction has altered the landscape of Columbia. The text and images in this book offer glimpses of past times and places—of the seeds that sprouted to be the Columbia of the twenty-first century.

ACKNOWLEDGEMENTS

I wish to acknowledge the assistance of Beth Bilderback, Robin Copp and Allen Stokes of the South Caroliniana Library; Steve Tuttle, Bryan Collars, Marion Chandler, Paul Begley and Ben Hornsby of the South Carolina Department of Archives and History; Debra Bloom at the Richland County Library; and the staff of the State Library. As always, special thanks are due my family—Terry, Jacob, Cassandra, Johnny and Keiser.

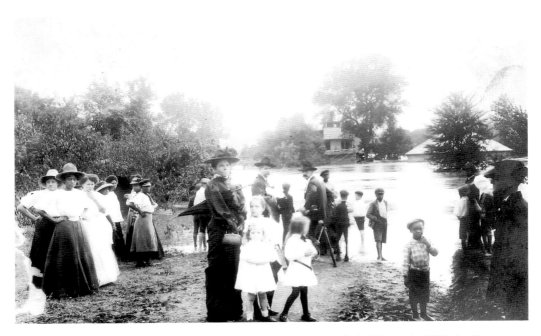

"The Great Flood" of 1908. Prior to the construction of the dam at Lake Murray in 1930, the Congaree River periodically overflowed its banks. At times, the rising river disrupted water and electrical service for the city of Columbia. Spectators gathered to view the raging river and the flooded waterworks and power house. *(photograph M-PL-C-FS-11) Courtesy of South Caroliniana Library, University of South Carolina, Columbia.*

INTRODUCTION

The history of Columbia is a tribute to its location near the center of the state. It began with South Carolina's native peoples developing trading paths in the fall zone between the rolling piedmont and the sloping coastal plain. The confluence of the Broad and Saluda Rivers to form the Congaree made the area an attractive way station. The rapids formed by the thirty-six-foot drop of the Congaree interrupted river transport. The site of Columbia lay between the juncture of the Broad and Saluda and above the fork of the Congaree and Wateree.

Probably the first Europeans to visit the Midlands were Hernan DeSoto and his Spanish conquistadors in 1540. By the time the English settled at Charlestown in 1670, the area was a natural crossroads for north—south, east—west trading and raiding parties. By 1718, the Congarees (modern Cayce), a little south of the union of the Broad and Saluda, was home to a fort and a trading post. In the 1730s, government leaders selected a site across the Congaree for the township of Saxe Gotha. In 1754, there was enough commerce to justify the establishment of Fridig's or Friday's Ferry across the Congaree. Roads to Charleston, Camden, Augusta and the backcountry converged on the ferry.

HISTORICAL OVERVIEW OF COLUMBIA

The choice of Columbia as the capital of South Carolina was a political compromise. By the 1760s, population growth in the backcountry had surpassed that of the Lowcountry. Yet Charles Town continued to be the seat of record for all land and court proceedings, and legislators from the Lowcountry continued to dominate the Commons House of Assembly. Backcountry residents lobbied for local courts with improved access to justice and for equal representation in the legislature. The Circuit Court Act of 1769 began the process that after the American Revolution produced the new capital.

In 1786, State Senator John Lewis Gervais (Ninety Six District) and Representative Henry Pendleton pushed to move "the seat of government from Charleston." They favored a site near Friday's Ferry. After much acrimonious debate and the consideration of several competing locations, the Friday's Ferry site triumphed by a vote of 65 to 61. In a related vote, the name "Columbia" prevailed over "Washington" by a vote of 11 to 7. The new town occupied a two-mile-square site on a plain along the eastern side of the Congaree River and included the plantation of Thomas and James Taylor.

By May 1786, the commissioners (James Taylor, Robert Lithgow and Benjamin Waring) appointed by the legislature to lay out the new city were at work. They divided the two-square-mile site into forty blocks of four acres each. The new town was a grid crisscrossed by 100-foot-wide streets and two major avenues of 160 feet—Assembly (north–south) and Senate (east–west). There were ten streets to the mile, which produced ten blocks to each mile.

North–south streets parallel with and east of Assembly were named for Revolutionary militia heroes—Richardson (Main), Sumter, Marion, Bull, Pickens, Henderson, Barnwell, Winn (Gregg), Laurens and Harden. Streets west of Assembly bore the names of Continental officers—Gates (Park), Lincoln, Gadsden, Wayne, Pulaski, Huger, Williams, Gist, Pinckney and Roberts. East–west streets parallel with Senate honored South Carolina history and industry. South of Senate the streets were Pendleton, Medium (College), Devine, Green, Blossom, Wheat, Rice, Tobacco, Indigo (Whaley) and Lower Boundary (Heyward).

North of Senate, the streets were Gervais, Lady (in honor of Martha Washington), Washington, Plain (Hampton), Taylor, Walnut (Blanding), Laurel, Richland, Lumber Street (Calhoun) and Upper Boundary (Elmwood Avenue).

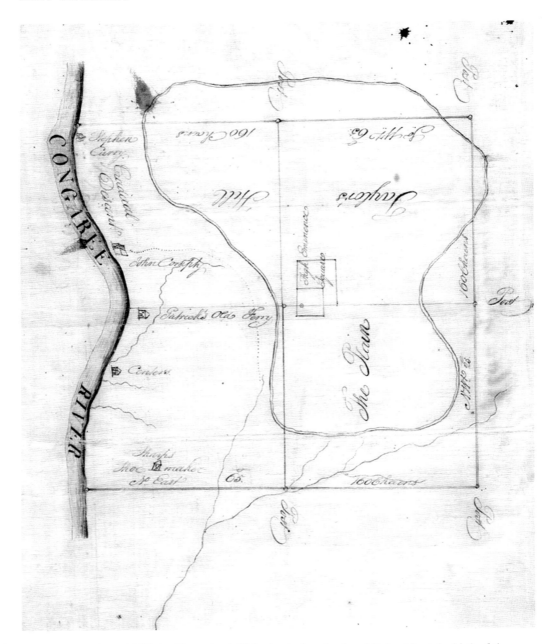

Plat of Columbia, 1786 (Taylor Plantations). This plat depicts the site of Columbia at the birth of the city. The 1786 act to acquire land and lay out the city reserved to Thomas Taylor, James Taylor and other landowners who had already built homes on the site two acres "in the said town, including their dwelling houses." *Courtesy of South Carolina Department of Archives and History.*

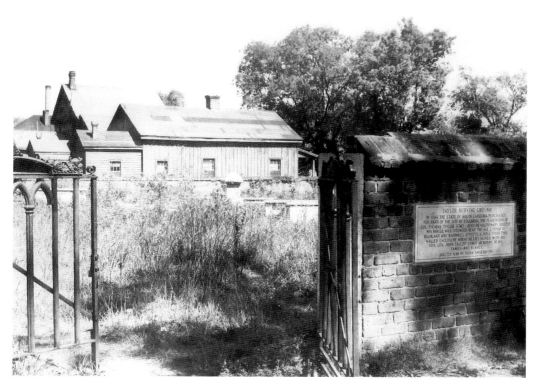

Taylor burying ground, Richland and Barnwell Streets, 1930s photograph. Among those buried here were Colonel Thomas Taylor and his son John Taylor. John Taylor served as Columbia's first mayor in 1806 and as governor of South Carolina from 1826 to 1828. The home of Colonel Thomas Taylor was near the cemetery. *(photograph WPA-PL-C-11-10) Courtesy of South Caroliniana Library, University of South Carolina, Columbia.*

Early Beginnings

From a little sleepy village to a large and beautiful city.
—*J.F. Williams*

Although the first city lots were sold on September 2, 1786, the town grew slowly and the South Carolina General Assembly did not hold its first official meeting in the new capital until January 1790. During the Constitutional Convention of May 1790, a move by Charleston delegates to return the capital to Charleston was barely defeated, 109 to 105. The resulting Constitution of 1790, South Carolina's third constitution, ended the controversy and fixed Columbia as the permanent capital of the state.

In May 1791, during his visit to the capital, President George Washington described Columbia as an "uncleared wood, with very few houses in it, and those all wooden over. The State House (which is also of wood), is a large and commodious building, but unfinished." Yet entrepreneurs such as Samuel Green moved to the new town and erected stores and hotels to house the legislators when the legislature was in session (the

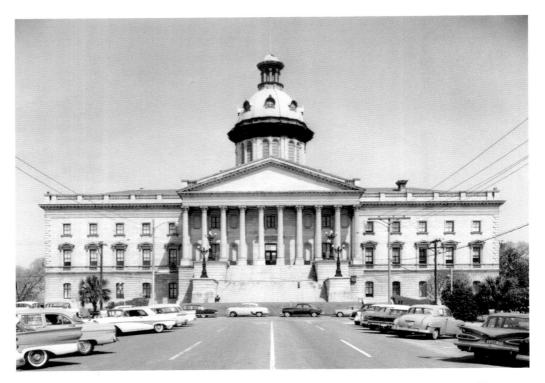

South Carolina State House, south façade, 1960. This building is South Carolina's second State House. The first, completed in 1789, was a two-story wooden structure located on a hill bounded by Gervais, Assembly, Senate and Richardson (Main) Streets and facing Main Street. In February 1865, fire destroyed the first structure. John Rudolph Niernsee designed the second (present) State House. Construction began in 1859, but was not completed until 1907. Since that time, the building has undergone a number of modifications and renovations. *Jack Boucher, photographer. HABS SC, 40-COLUM,9-1. Courtesy of Library of Congress.*

month of December). In 1793, Green lamented that "stores were increasing so fast" that he doubted there was enough business to sustain them.

Business improved when the South Carolina legislature created Columbia's first local government—a board of commissioners of streets and markets. In 1799, the legislature named Columbia the seat of Richland District. With that designation came a courthouse, jail and other county offices. Columbia now had a year-round workforce to support commerce that developed along Richardson (Main) and other blocks near the capitol. Incorporated in 1805, Columbia took another step forward in 1806—self government. The residents of Columbia elected their first intendant (mayor), John Taylor. In 1805, Columbia had cotton gins, iron foundries, a ropewalk and a paper mill.

In 1801, John Drayton commended the location of the State House "on a beautiful eminence" and described Columbia as a town of about 200 wooden "respectable" looking houses generally painted yellow and gray. By 1816, the local newspapers reported that Columbia had 250 houses and a population of one thousand.

Columbia had churches as well. As early as 1787, a Methodist circuit rider conducted the first worship service in the new town. By 1826, Columbia had flourishing Methodist,

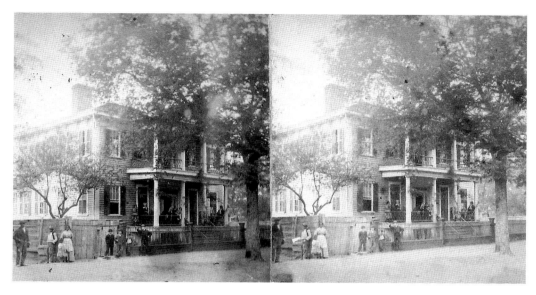

Mrs. Wyatt's Boarding House, Columbia, circa 1876. From the city's inception, boardinghouses were a way of life for many Columbia residents—students, legislators, business and professional men. They provided long-term and less expensive housing and board than the city's hotels. The quality of the "board" varied. For example, in 1883, Mark Reynolds wrote his sister that he expected breakfast to improve once the Supreme Court was back in session. Note the boarders sitting on the front porch. This Mrs. Wyatt may be the fifty-year old widow—Sara L. Wyatt—who lived with her son on Blanding Street in 1880. Sara Wyatt was a native of New York. *Stereograph by Wearn & Hix (photograph 12484). Courtesy of South Caroliniana Library, University of South Carolina, Columbia.*

Presbyterian, Baptist, Episcopal and Catholic churches. In 1811, a young Charlestonian visiting Columbia complained that "many families here are Methodist."

The founding of South Carolina College in 1801 was a major enhancement to the cultural and commercial life of Columbia. Set in a, at that time, remote site, when it opened in 1805, the college attracted first-class faculty, including Thomas Cooper and James H. Thornwell, and students from across the state. Like the central location of the capital, South Carolina College was a unifying force for the inhabitants of South Carolina. Students from all parts of the state enrolled. In 1820, Thomas Cooper (controversial president of South Carolina College from 1821 to 1834) sang the praises of Columbia as "a very healthy place…high, dry & sandy" with 3,500 residents and approximately 400 houses.

Visit of Lafayette

In addition to President Washington, Columbia had another illustrious Revolutionary hero visit. The Marquis de Lafayette came to America in 1824, but did not reach Columbia until March 1825. The legislature and city honored Lafayette with a parade, receptions, speeches and a great ball. Arches decorated with flowers and greenery lined Main Street. South Carolina College declared a student holiday. Governor Richard I. Manning rode

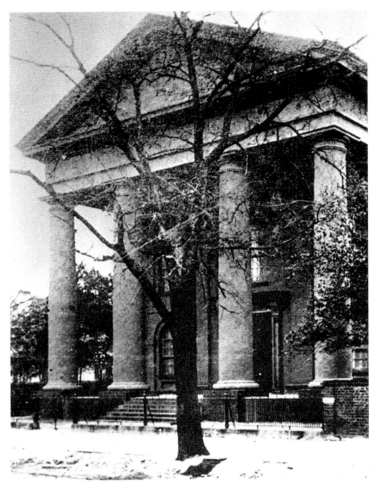

Left: First Baptist Church, Hampton Street, Columbia, circa 1875. Completed in 1859, this structure housed one of the early religious congregations in Columbia. Organized in 1809, this was the second house of worship on this site. Many individuals important to the development of Columbia are buried in the churchyard. *HABS SC, 40-COLUM, 5-1. Courtesy of Library of Congress.*

Below: University of South Carolina Campus, 1820. The original South Carolina College buildings were brick, and in 1801 the site was distant from commercial and residential areas. By 1820, the college had several buildings standing along the Horseshoe—Rutledge College (1805), DeSaussure College (1809), the President's House (1810) and McCutchen House (1813). *Drawing by Catherine Rembert (photograph M-PL-C-CS-8). From a copy, courtesy of South Caroliniana Library, University of South Carolina, Columbia.*

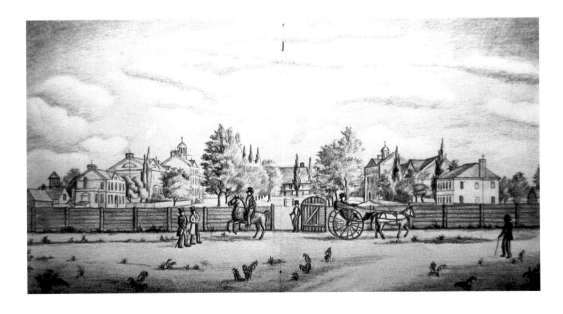

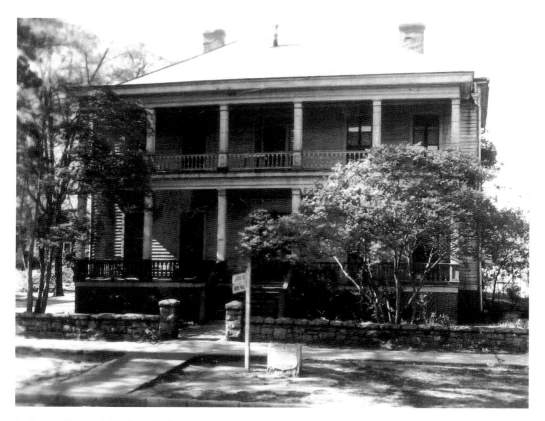

Lafayette House, 1409 Gervais Street, 1930s photograph. Torn down in 1944, this handsome home characterized the stately homes of pre–Civil War Columbia. In 1824 and 1825, the Marquis de Lafayette (1757–1834) toured the United States with his son George and secretary Auguste Levasseur. Lafayette, whose given name was Marie Joseph Paul Yves Roch Gilbert du Motier, stayed in this house during his March 1825 visit to Columbia. Lafayette was a French nobleman who sailed to America in 1777 to fight for American independence. He enlisted in the Continental army and with the rank of major general served on the staff of General George Washington. At the time of Lafayette's visit, this house was the home of Isaac Randolph, transportation entrepreneur. At one time, the plaque that commemorated Lafayette's visit was located in the parking lot of S&S Cafeteria. *(photograph WPA-PL-C-H-1) Courtesy of South Caroliniana Library, University of South Carolina, Columbia.*

out to meet Lafayette and William C. Preston, Manning's aide, who had joined Lafayette at the North Carolina line and escorted him to Columbia. The mayor welcomed Lafayette at the corner of Main and Gervais Streets, and uniformed troops lined his way to his temporary residence, the home of Isaac Randolph on Gervais Street.

Public Works

Columbia launched its first public works in 1818—an effort to provide a safe and dependable water supply. The waterworks, begun in 1818, were finished in 1821. Colonel Abram Blanding designed the works, which diverted springs to form a reservoir in what

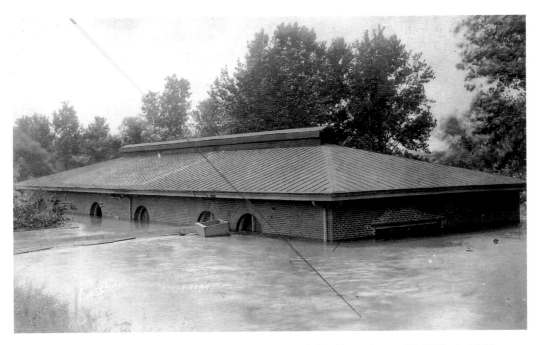

Powerhouse flooded, 1908. The crest of the freshet reached Columbia on August 27, 1908. At 11:00 p.m., the Congaree River was thirty-six feet deep. The force of the flood waters damaged the steel railroad bridge and the power plant for the electric streetcars and swept a small cottage at the canal locks into the Columbia Canal. *(photograph M-PL-C-FS-8) Courtesy of South Caroliniana Library, University of South Carolina, Columbia.*

is now Finlay (Sidney) Park. Public baths adjoined the waterworks. Later, the waterworks were relocated to the riverbank north of the penitentiary near the junction of the Broad and Saluda Rivers.

Also in 1818, the South Carolina General Assembly appropriated money to improve the state's rivers. As a result, Columbia benefited from the construction of the Columbia Canal, the Saluda Canal and the Bull Sluice Lock. These "internal improvements" were needed because the Congaree River dropped thirty-six feet between the confluence of the Saluda and Broad, north of Columbia, and Granby, south of the city. The Columbia Canal, built along the east bank of the river, was de facto part of the city's western boundary. While designed for transportation, the Columbia Canal would later prove beneficial to Columbia in other ways.

The canals, steamboats and other river craft connected Columbia with the upstate and coastal areas. There was also a ferry across the Congaree. These boats docked at the foot of Upper or Boundary Street (Elmwood Avenue). Among the cargo coming up Elmwood to Columbia was cotton. As a result, the area around Elmwood and Main Street where farmers and cotton factors met became known as "Cotton Town." Near Cotton Town was "Butcher Town," where the town's butchers prepared meat for sale in the market.

The first cemetery lay between the State House and the Congaree River. Mentioned in 1805 as the Old Potter's Field, burials were in the block bounded by Senate, Pendleton,

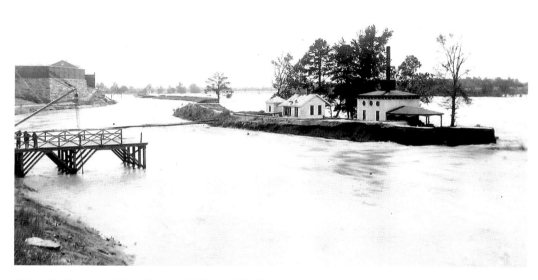

Columbia Canal and river flooded, 1886 or 1887. Constructed between 1820 and 1824, the Columbia Canal provided a way to navigate around the rapids where the Broad and Saluda Rivers meet to form the Congaree River. The 1824 canal began between Lumber (Calhoun) and Richland Streets and ended across from the Granby landing. *Photograph by Hennies & Bucher (photograph M-PL-C-FS-1). Courtesy of South Caroliniana Library, University of South Carolina, Columbia.*

Wayne and Pulaski Streets. Later, Potter's Field ceased to be a burying ground, and the city sold the site to the Atlantic Coastline Railroad for a freight yard.

By the 1820s, Columbia was a business center. Robert Mills in his *Statistics* (1826) noted the recent rapid population growth and the fact that Charleston and upstate merchants had moved to Columbia or opened branch offices there. His *Statistics* provided a snapshot of life in Columbia. By 1826, the city boasted a population of four thousand, with five hundred—some "handsome"—houses. Prior to 1826, a major fire had destroyed portions of Columbia's commercial area.

In addition to South Carolina College with its distinctive Horseshoe, Columbia had two female educational institutions in 1826. One was the Columbia Female Academy, a predecessor of the South Carolina Female Institute (Barhamville Academy) that by the Civil War had moved to the city's outskirts. Among other schools, there was also a male academy. While Columbia had a number of fine churches, only the Baptists had erected a brick building. Columbia had a city hall with a clock, a courthouse and jail and several libraries.

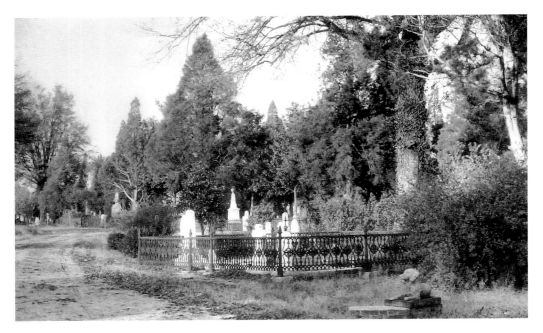

Scenes at Elmwood Cemetery, 1905. Elmwood, organized in 1854, originally was Columbia's answer to Boston's Mount Auburn, the first rural cemetery in America. Among other notables buried there are Milledge Luke Bonham, governor of South Carolina, and United States Senator Christie Benet. Art Work of Columbia, *part 4. Courtesy of South Caroliniana Library, University of South Carolina, Columbia.*

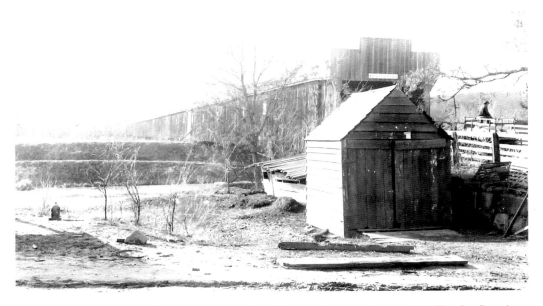

Toll bridge just above Camp Fornance, crossing Broad River and the canal, circa 1899. The first Broad River bridge was built in 1829. In 1865, retreating Confederates, as a delaying tactic, burned the Broad River and other bridges leading into Columbia. In 1870, this 1,060-foot-long covered bridge replaced the destroyed one. It remained a toll bridge until 1912. After barely surviving the flood of 1908, the bridge burned in 1925. Sign above the bridge entrance reads, "Walk your horses." *Photograph by Harry M. King (photograph 12050.28). Courtesy of South Caroliniana Library, University of South Carolina, Columbia.*

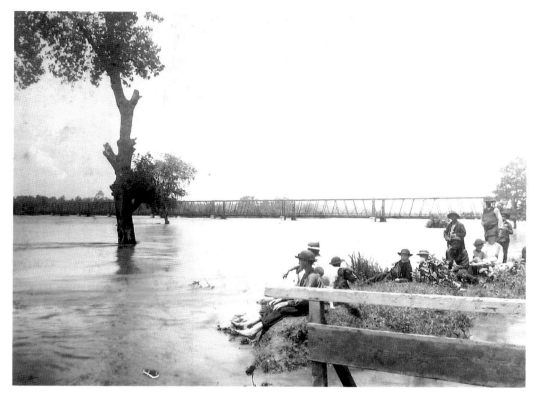

Gervais Street Bridge in flood, 1886 or 1887. Rebuilt in 1870, this bridge replaced one destroyed in 1865. The bridge was in private hands and was a toll bridge until Richland and Lexington Counties bought it in 1912. The current Gervais Street Bridge dates from 1927 and replaced this one. *Photograph by Hennies & Bucher (photograph M-PL-C-FS-2). Courtesy of South Caroliniana Library, University of South Carolina, Columbia.*

By 1828 there were bridges, financed by private investors, over the Congaree, Saluda and Broad Rivers, making it easier to reach the capital city by land. Columbia, with its governmental, educational and public facilities, was an attractive place to live. In 1852, Columbia had gaslights along its streets.

However, the arrival of the railroad diminished the value of river transportation. Prior to the Civil War, a number of railroads served Columbia. The first to arrive was the Louisville, Cincinnati & Charleston Railroad Company. In 1842, a great celebration greeted the arrival of the first train from Charleston to Columbia. The railroad depot was at Gervais and Gadsden Streets. Also in the 1850s, two other railroads connected Columbia with Charlotte and Greenville. The Charlotte line (1852) ran from a depot at Blanding and Barnwell Streets, and the Greenville line (1853) from the Gervais Street depot.

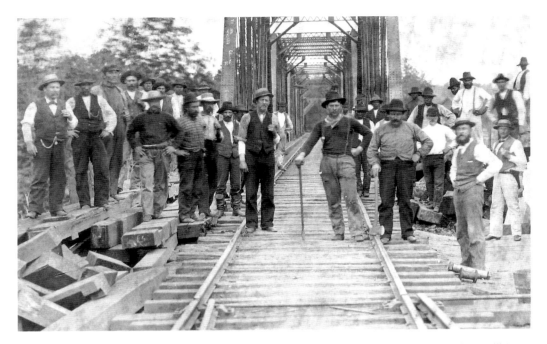

Crew laying railroad tracks by iron bridge, John W. Fry, superintendent, C&G (Columbia & Greenville) Railroad, circa 1880s. In 1880, John Fry was a twenty-eight-year-old railroad engineer boarding on Lady Street in Columbia. He lived in a neighborhood with other railroad employees. *(photograph 9222.5) Courtesy of South Caroliniana Library, University of South Carolina, Columbia.*

Nullification

States' rights, particularly the right to "nullify" federal legislation, burned brightly in antebellum Columbia. Conventions met there to discuss nullification, states' rights and possible responses. One of these provoked president and native son Andrew Jackson's threat to send troops to South Carolina unless the state withdrew its Ordinance of Nullification. At the last convention in 1852, South Carolina was ahead of its time. It wanted a congress of Southern states to consider the issue of secession and the other Southern states were not ready for that step. By 1860, the election of President Abraham Lincoln altered that situation.

State House

The State House stood in the center of Columbia, as Columbia stood in the center of South Carolina. The original wooden building stood on a hill overlooking the river. The site covered one city block bounded by Gervais, Senate, Assembly and Richardson (Main) Streets. Completed by the end of 1789, the first State House, perhaps designed by James Hoban, faced Main Street. By the 1850s, the building had deteriorated and construction began on a new State House wing in 1851. To accommodate the new State House, which faced Gervais and truncated Main Street, the old building was moved in

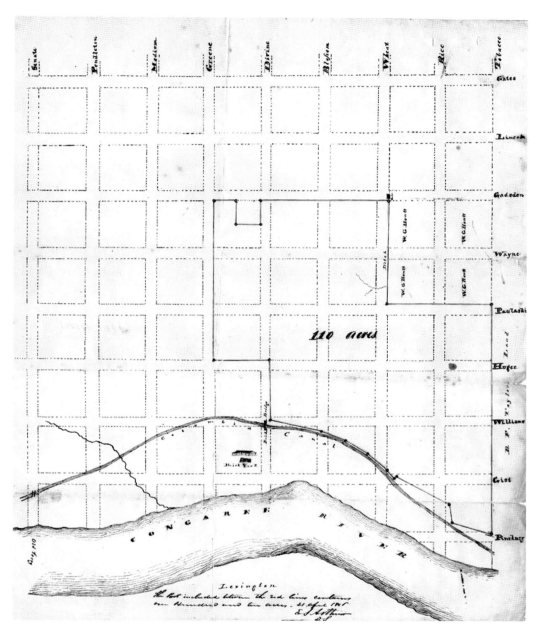

In 1846, Sarah Taylor, wife of B.F. Taylor, purchased 110 acres bordered by the Columbia Canal, including several Columbia city blocks, from R.A. Brown. This plat shows a brickyard and land owned by W.G. Hunt as well as the canal. In 1860, B.F. and Sarah Taylor were among the larger slave owners in Richland County. *Courtesy of South Carolina Department of Archives and History.*

1854. While substantial work was done on the structure under the direction of Major John R. Niernsee prior to the Civil War, the war and wartime shortages delayed work on the new State House. The old State House burned on February 18, 1865, and the new one was damaged by mortar attacks and fire.

On the Brink of War

In 1856, according to J.F. Williams, Columbia had a population of roughly 3,500, organized into three wards as follows: ward one, from Lower (Heyward) Street to the State House ("mostly woods" and "sparsely settled"); ward two, from the south side of Gervais to the south side of Plain (Hampton); ward three, from Plain to Laurel; and ward four, from Laurel to Elmwood. The city limits ended at Elmwood. Elmwood was the parade ground for the militia and beyond it lay the state fairgrounds.

The mayor of Columbia was E.J. Arthur and John Burdell was chief of police. The police had a two-story brick guard house on Main Street, and the adjacent jail faced Washington Street. City hall, with a market on its lower level, stood at the corner of Washington and Main Streets. City hall had a tower over the sidewalk that contained the town clock and fire bell.

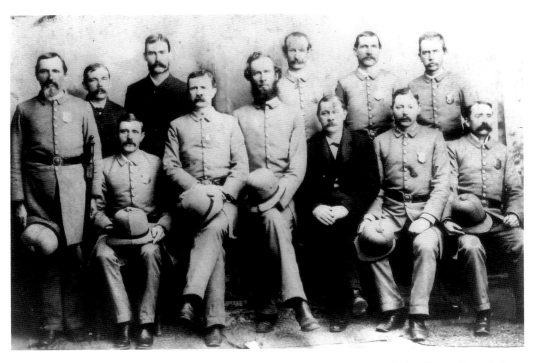

Columbia Police Force, 1865. In 1860, forty-six-year-old John Burdell was chief of police and boarded with Delicia C. Speck. According to E.F. Williams, Columbia's policemen were William Baugh, Michael Greimstead, Jacson Starling, James W. Sill, J.M. Coker, Thomas Harrison, Paul Bofil, W.C. Strickland and James W. Rose. *(Samuel Latimer Papers, 22-968) From a copy, courtesy of South Caroliniana Library, University of South Carolina, Columbia.*

Slave house of Charles Mercer Logan, Senate and Assembly Streets. According to the 1860 Census, Logan was a native of Ireland. Age forty-four in 1860, Logan listed his occupation as "negro trader" and owned real estate valued at $6,000 and personal property (including fifteen slaves) worth $2,000. This secured building probably housed slaves awaiting sale. After the Civil War, Logan pursued real estate and other enterprises and died a wealthy man leaving a number of philanthropic bequests. The intersection of Senate and Assembly Streets is now part of the capitol complex. *Sargeant Studio (photograph WPA-PL-C-M-4). Courtesy of South Caroliniana Library, University of South Carolina, Columbia.*

Civil War

In 1860, Columbia had 4,395 white and 3,657 African American inhabitants, and secession was in the air. For many, the election of Abraham Lincoln that fall was the last straw. On November 13, 1860, the South Carolina General Assembly enacted legislation that called for a "Convention of the People" to be held in Columbia on December 17, 1860.

As the meeting date drew near, Columbia was crowded with visitors and buzzing with speeches. Hotheads tarred and feathered a local businessman considered an abolitionist. On December 17, 1860, the state of South Carolina in convention met at the First Baptist Church on Plain (Hampton) Street in Columbia to consider the question of secession. The interior of the church was "frigid" and an outbreak of smallpox plagued the capital.

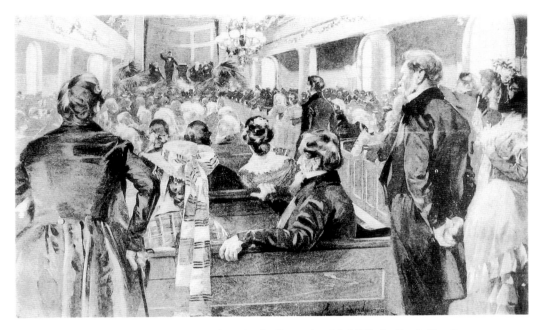

Secession Convention inside First Baptist Church. On December 17, 1860, the South Carolina Convention to consider secession first convened in the new sanctuary of the First Baptist Church. Shortly thereafter, the convention moved to Charleston and the Ordinance of Secession was signed there. Reasons for the move range from an outbreak of smallpox in the capital city to the drafty, poorly heated sanctuary. *(photograph M-PL-C-C-2) From a copy, courtesy of South Caroliniana Library, University of South Carolina, Columbia.*

Consequently, the convention adjourned to Charleston and it was there on December 20, 1860, that all 169 delegates signed the Ordinance of Secession. The announcement of secession triggered bell ringing, bonfires, cannon fire and celebration in the streets of Columbia. Military companies paraded and almost every student at South Carolina College enlisted. Residents erected a liberty pole at the corner of Washington and Main Streets.

In many ways, Columbia profited from the war. The city became a manufacturing center and a sanctuary for human and paper refugees. Many district courts, such as Beaufort, sent their records to Columbia for safekeeping.

Displaced families, such as the Leveretts of Beaufort, sought the comparative safety of Columbia. Even Camden's famous diarist Mary Boykin Chesnut made her wartime home in Chesnut Cottage on Hampton Street. There, on October 5, 1864, Jefferson Davis, president of the Confederate States of America, visited the Chesnuts and addressed the citizens of Columbia. Refugees came from as far away as New Orleans.

The population of Columbia doubled. Living space, food and clothing were in short supply, and as the war progressed, food supplies became more limited and costly. By 1865, flour cost $400 a barrel.

Columbia was a center of military preparedness, but not a heavily defended city. Troops trained at the old fairgrounds on Elmwood and later Lightwood Knot Springs near Killian. The post quartermaster had an office near the market. Buildings at South

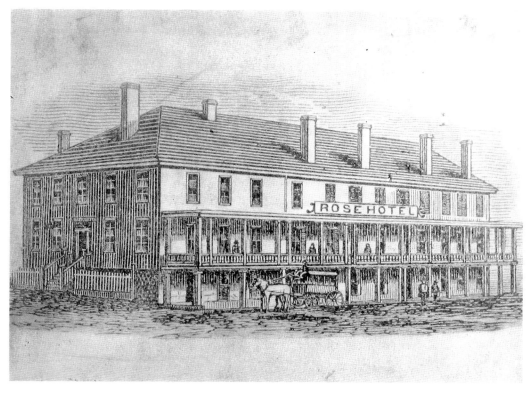

Rose Hotel. This drawing resembles photographs of the Congaree Hotel on the corner of Gervais and Assembly Streets. In 1885, the hotel's proprietor was W.H. Rose. On April 30, 1891, at the Stack and Roof railroad grading camp about ten miles south of Columbia, Tom Stack shot John Hammett. The injured man was transported from the scene to a room at the Rose Hotel, where he died on May 1, 1891. *(photograph M-PL-C-B-15) From a copy of a drawing, courtesy of South Caroliniana Library, University of South Carolina, Columbia.*

Carolina College were used as hospitals and the fairground buildings housed a chemical laboratory that produced alcohol. Across the river, the Saluda factory manufactured cloth for uniforms. There were four printing plants in Columbia, including Evans & Cogswell, which printed money for the Confederacy. The city was also an important manufacturing center during the war. Factories produced swords, socks, buttons, bayonets and matches. Near the State Hospital was the nitre bureau, a saltpetre factory. The Palmetto Iron Works produced cannon and minie (small arms ammunition) balls. In addition, almost all the banks in the state relocated to Columbia. The city was a beehive of activity.

In addition to voluntary refugees, Columbia housed Union prisoners during the war. There was a stockade near the Saluda factory, known as Camp Sorghum, and later the prisoners were moved to the State Hospital grounds. Guards patrolled Main Street checking exemption papers and identifying potential recruits for Confederate service. Isabella D. Martin of Columbia established the first Wayside Hospital near the South Carolina Railroad depot. It treated one thousand soldiers during its first year of operation. The idea spread to other Confederate cities. Columbia residents supported

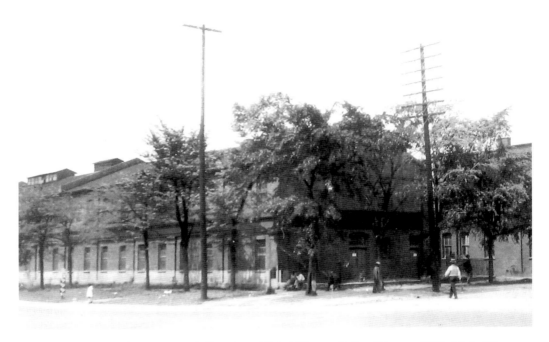

State Dispensary, northwest corner of Gervais and Pulaski Streets. Before February 1865, this building housed the Confederate Printing Plant. Rebuilt and purchased by the State of South Carolina, the building was the State Dispensary warehouse from 1895 to 1907. *(photograph Blackburn Album) Courtesy of South Caroliniana Library, University of South Carolina, Columbia.*

the war, and at a three-day bazaar that opened on January 17, 1865, they raised over $24,000 for the Wayside Hospital.

1865

The city is in a deplorable state.
—*Robert W. Gibbes*

By 1865, Columbia was in a desperate situation. Profiteering and unlicensed saloons stretched the available police force. With the gaslights not functioning, Columbia's streets were unlit after dark. Law enforcement after dark was problematic; most men were in service, and by February residents knew that General William T. Sherman was in South Carolina. On Valentine's Day, residents heard the distant boom of cannon. Many residents tried to flee the city. Several state officials successfully dispatched valuable state archives on rail cars to safety.

On February 16, Federal forces established a battery across the Congaree and began shelling Columbia. That evening, Governor Andrew J. McGrath left the city. General

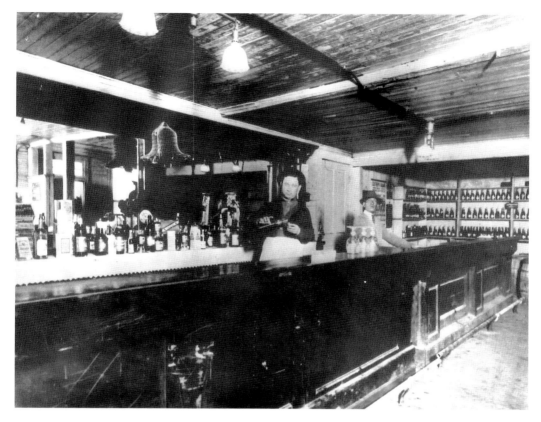

Main Street Saloon, 1865. According to an 1860 city directory, Columbia had fourteen saloons—all located on Richardson (Main) Street. *(Samuel Latimer Papers, 22-968) Courtesy of South Caroliniana Library, University of South Carolina, Columbia.*

Joseph Wheeler's Confederate troops burned the Congaree Bridge and looted Main Street stores. Lieutenant General Wade Hampton, now in control of Columbia's defense, informed the mayor that he and his cavalry would pull out of the city the morning of February 17. While Hampton and Wheeler evacuated the city, neither ordered cotton and liquor stores burned.

Despite the destruction of the Broad River bridge, on February 17, Union forces under the command of Colonel George Stone crossed the Broad River on a pontoon bridge to accept Mayor Thomas Goodwyn's surrender of the city. The two met on River Drive at Beaufort Street. Union troops then marched into Columbia and began looting stores on Main Street. General Sherman established his headquarters in Colonel Blanton Duncan's home at 1616 Gervais Street.

An explosion rocked the South Carolina Railroad depot. Around 7:00 p.m., three rockets flared over the State House, and fires broke out across Columbia. Bales of cotton burned at the intersection of Main and Assembly Streets. High winds fed the flames, and drunken soldiers roamed the streets. By 3:00 a.m. the next morning, a wide swathe of Columbia had burned. Despite a few stories of gallant Union soldiers protecting private

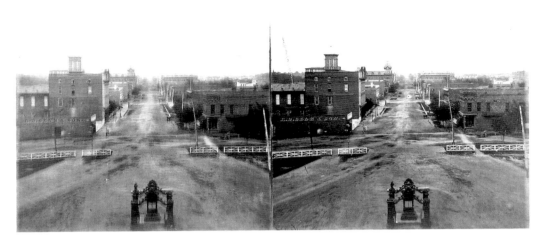

An unpaved Main Street looking north from the State House, 1870s. On the left stands Rufus D. Senn's grocery. Senn, a native of North Carolina, was forty-six years old in 1870. It was 1907 before Columbia began paving Main Street. *Stereograph by W.A. Reckling (photograph 12932). Courtesy of South Caroliniana Library, University of South Carolina, Columbia.*

property, it was a night of great destruction and despair. Men, women and children, black and white, were homeless in the chill February air.

Public buildings—including a number of churches, the State Armory, Arsenal and Palmetto Iron Works—businesses and private homes burned. The campus of South Carolina College, the State Hospital and the unfinished State House were among the survivors. When Union troops left on February 20, the "handsome place" and "elegant" houses described by Union Captain George W. Pepper were no more. As Dr. Robert W. Gibbes, whose own home burned, noted, Columbia was in "a deplorable state." According to Marion Lucas, fire swept down Richardson (Main) Street from Cotton Town to the State House, destroying buildings between Assembly and Bull Streets. Approximately a third of Columbia's buildings burned. Columbia's business district was in ashes, and much of Columbia's early history was gone.

Undaunted, almost immediately, the residents began to rebuild. Churches such as Washington Street Methodist found other meeting places and worked to hold their congregations together. Both Richland County and Washington Street built temporary abodes from salvaged brick. Some residents left Columbia, but other businessmen rebuilt their stores and prospered. Other residents were old, infirm and lacked opportunities to rebuild or relocate. A survey of Richland District including Columbia in 1867 documented 459 names, a total of 1,670 individuals, that needed daily assistance to survive. In May, the United States Army established military control of Columbia.

Yet Columbia and its people survived. They survived President Andrew Johnson's Reconstruction and they survived the harsher Reconstruction measures (military rule in 1867) of the Black Republicans in Washington. City leaders were Republicans and

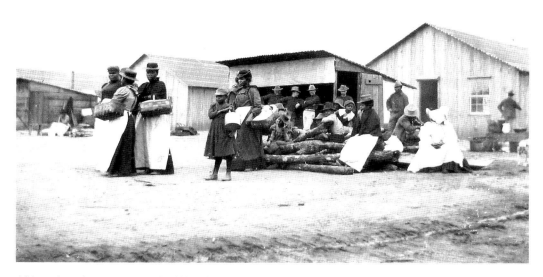

African American women and children in yard, circa 1899. These women and children are possibly vendors at Camp Fornance. Vendors peddled lemonade, pies, cookies and other delicacies to the soldiers. In December 1898, General Cole, the commanding officer, judged such foodstuffs as detrimental to the health of his soldiers and attempted to ban vendors from the camp. *Photograph by Harry M. King (photograph 12050.34). Courtesy of South Caroliniana Library, University of South Carolina, Columbia.*

Democrats. Republican governors ranged from the ridiculous Franklin J. Moses Jr. to the respectable Daniel Chamberlain. Efforts at racial harmony succeeded in Columbia as residents put commerce over politics. On the other hand, African Americans, while serving in the state legislature and the United States Congress, never advanced higher than lieutenant governor in their quest for statewide office.

Nevertheless, African Americans established businesses and developed new neighborhoods. In 1860, the census reported that Columbia had 319 free African Americans, including the famed musician Joe Randal, and 2,809 slaves. There were two main concentrations of African Americans in Columbia—in the area between Main, Elmwood, Pickens and College and the one bounded by Gervais, Gadsden, Elmwood and Main. With the end of slavery and greater mobility, African Americans developed new, distinct neighborhoods, such as the area around the State Hospital and Wheeler Hill. They also gained two institutions of higher education—Benedict College and Allen University.

The Panic of 1873 affected recovery efforts. However, the state, county and city replaced their lost buildings. With the old State House gone and the new one still unfinished,

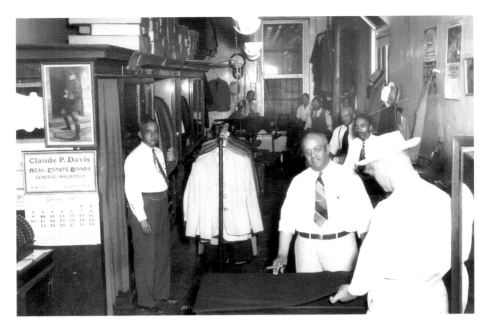

Owen and Paul Tailor Shop, Washington Street, 1946. This establishment had a long tenure on Washington Street between Main and Assembly. *(John H. McCray Papers) Courtesy of South Caroliniana Library, University of South Carolina, Columbia.*

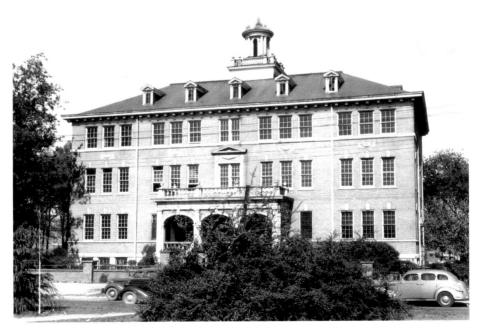

Chappelle Administration Building, Allen University, Harden and Taylor Streets, 1930s. The African Methodist Episcopal Church founded Allen University in 1881. Construction of the administration building began in 1922 and the building opened in 1925. In 1930, the university's library occupied the first floor of the administration building. Allen University has the distinction of being an African American educational institution founded by African Americans. *(photograph WPA-PL-C-V-5) Courtesy of South Caroliniana Library, University of South Carolina, Columbia.*

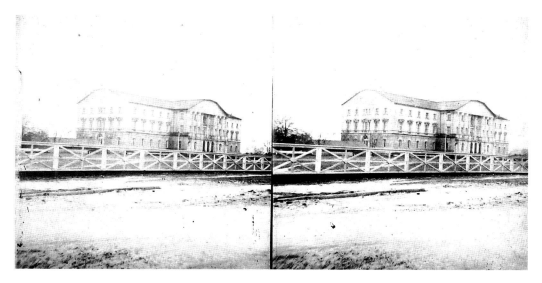

State House, 1870. The Civil War and the burning of Columbia in 1865 interrupted work on the new State House. This photograph shows the State House after a temporary roof was added in 1867–68. On the left a construction shed is visible. *Stereograph by W.A. Reckling (photograph 12324). Courtesy of South Caroliniana Library, University of South Carolina, Columbia.*

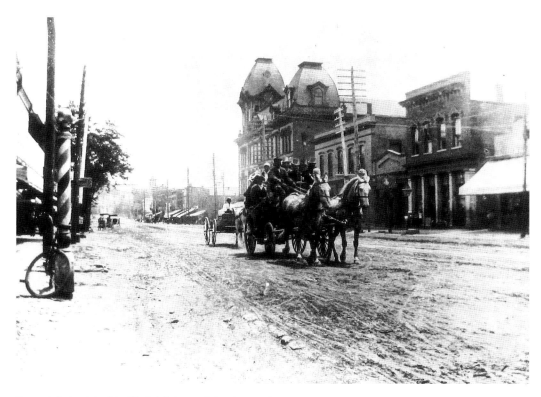

Second Columbia City Hall, Main and Washington Streets. Built in 1874, the building burned in 1899. In February 1891, the *State* began publication in this building, but later moved to 1220 Main Street. *(Samuel Latimer Papers, 22-970) From a copy, courtesy of South Caroliniana Library, University of South Carolina, Columbia.*

the South Carolina legislature met at South Carolina College. Between 1867 and 1868, under John R. Niernsee's supervision, the new State House gained a temporary tin roof. In fits and starts, by 1871 the building was ready for temporary occupancy, although a leaking roof was a recurring problem.

Richland County, having lost its courthouse during the burning of Columbia, occupied a temporary facility, Carolina Hall, from 1868 to 1874. In 1874, the county erected a new courthouse on the northwest corner of Washington and Sumter Streets. This building served until it was torn down in 1935. Also in 1874, the city of Columbia built a new elegant and expensive city hall on the site (Washington and Main) of the burned one. The new facility included an opera house. Fire destroyed this "conspicuous landmark" on March 30, 1899.

On May 1, 1875, Columbia experienced another setback on its road to recovery. That afternoon, a tornado struck Columbia, demolished the steeple of the First Presbyterian Church, blew off the roof of the market and damaged the Greenville and Columbia and South Carolina Railroad depots.

The election of 1876 was hotly contested. Both Republicans and Democrats alleged voter fraud and claimed victory. As a result, Columbia was home to two competing Houses of Representatives—the Wallace House (Democrats) and the Mackey House (Republicans)—and two governors, Wade Hampton (Democrat) and Daniel Chamberlain (Republican).

Swept into the contested presidential election of Rutherford B. Hayes, the Hampton-Chamberlain controversy ended with Democratic victory. By 1876 and the end of Reconstruction, Columbia was a changed place. In 1883, Main Street bore few traces of

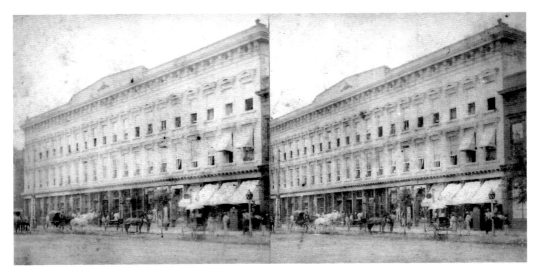

Columbia Hotel, 1531 Main Street, circa 1876. During its long history, the capital city has seen several hotels named Columbia. As early as 1812, P. Lalanne Delane advertised a Columbia Hotel "opposite the State House" in the Charleston *City Gazette*. In the 1890s, the renowned Columbia Hotel was the scene of balls, benefits and conventions. In 1891, the *State* newspaper carried an ironic announcement: The chief clerk of the Jerome Hotel held his wedding at the Columbia Hotel. By 1927, the hotel was gone. *Stereograph by Wearn & Hix (photograph 12759). Courtesy of South Caroliniana Library, University of South Carolina, Columbia.*

the 1865 fire. It bustled with trade and by 1880 the city had a population of 10,036. Ten years later, it had grown to 21,101.

Columbia improved its waterworks and added a telegraph alarm for police and fire. In 1880, Columbia had telephones. In 1891, the city converted its gas streetlights to electricity, and by 1894 the Columbia Electric Street Railway, Light and Power Company had the first electric streetcars in South Carolina. A steam electric facility near Gervais Street and a hydroelectric plant on the Columbia Canal powered the cars. Yet to some, the city appeared "awkward" and uncertain—a study in contrasts. Manicured lawns adjoined overgrown lots; brick walks gave way to muddy paths.

A New Century

Columbia—the City Unlimited.
—*James L. Mimnaugh*

Columbia was a city seeking an identity. It was a city caught up in the evangelistic fervor of the "New South." Frederick H. Hyatt and Edwin W. Robertson typified these New South entrepreneurs. After the Civil War, Hyatt became an insurance salesman. By 1892, he was the general agent for the Mutual Life Insurance Company in South Carolina. He also invested in banking and real estate. Robertson parlayed one small bank into the National Loan & Exchange Bank, the largest in the state, and built Columbia's first skyscraper, now known as the Barringer Building. Both invested in their community and supported cultural and educational enterprises. Both built large imposing homes—testaments to their attainments.

Despite these success stories, Columbia's economic recovery was uneven. Panics upset the marketplace and from 1875 to 1895 farm prices declined. Yet the churches, such as Washington Street Methodist, embraced the Annual Conference's call to establish Epworth Orphanage in 1894. The post-Reconstruction years were ones of reform. In 1883, Columbia women organized the first Women's Christian Temperance Union in South Carolina.

South Carolina politics changed in the 1880s and 1890s. The Hampton mystique waned, and the populist agrarian Benjamin R. Tillman gained the State House in 1890. Tillman was the first governor inaugurated on the steps of the new State House. Tillman's legacy was mixed. It included expanded educational opportunities as well as the graft-prone state dispensary (state-controlled liquor distribution) and the Constitution of 1895, which disenfranchised South Carolina's African Americans.

Yet the cotton industry was a bright spot for Columbia and South Carolina's economy. In 1880, South Carolinians produced more cotton then they had in 1860. With cotton came textile mills. By 1895, the Columbia Mills on Gervais Street was the first mill powered by electricity in the United States. Other mills followed; among them were Whaley (1895), Granby (1897) and Olympia (1899) to the south of Columbia. The cotton mills changed the city and state economically and socially. The mills built mill villages to house their workers. The villages had a different architectural style, and many millworkers were displaced agricultural workers from rural areas.

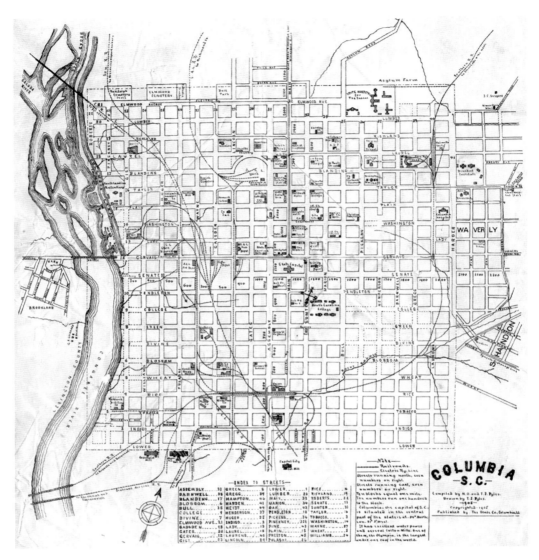

Map of Columbia, 1905. An immigrant to Columbia in March 1907 noted the unpaved streets, the trees and flowers, the absence of movie theatres and the dominance of horse-drawn transportation. However, in the city core, commercial enterprises dominated Main, Assembly and Gervais Streets. *Courtesy of South Carolina Department of Archives and History.*

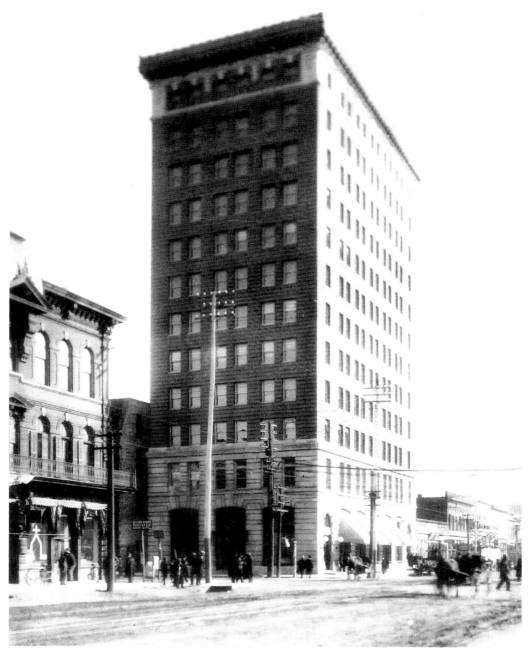

National Loan and Exchange Bank of Columbia Building (Barringer Building), corner of Main and Washington Streets, 1905. In Columbia's first skyscraper, the National Loan and Exchange Bank, the largest bank in South Carolina, occupied the first floor. The building was the brainchild of Columbia businessman E.W. Robertson, president of the National Loan and Exchange Bank. In 1904, the Metropolitan Club occupied the twelfth floor and a drugstore stood across Washington Street. Robertson also invested in the Arcade Mall, an enclosed shopping area that connected Main and Washington Streets. *Art Work of Columbia,* part 4. *Courtesy of South Caroliniana Library, University of South Carolina, Columbia.*

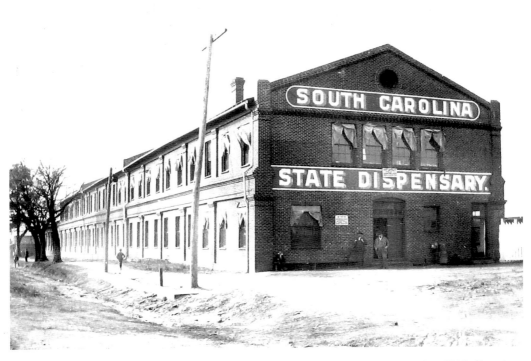

South Carolina State Dispensary ("where all of the Confederate money was made"), circa 1899, Gervais at Pulaski Streets. Evans & Cogsdell relocated their printing operation from Charleston to Columbia and built this building in 1863–64. Gutted by fire, the building was rebuilt and later housed the State Dispensary warehouse. The dispensary, a state effort to control the sale of liquor, operated statewide from 1893 to 1907. Charges of graft and corruption plagued the effort. *Photograph by Harry M. King Jr. (photograph 12050.5). Courtesy of South Caroliniana Library, University of South Carolina, Columbia.*

The Spanish-American War also altered the Columbia landscape. Camp Fornance on the Broad River trained soldiers for the Great War from 1914 to 1918. After the camp was disbanded, the area became a residential development. This early military installation pointed the way to a heightened military presence as the twentieth century unfolded.

From the 1880s forward, investors developed suburbs in unincorporated areas around the city. The growth of streetcar lines and the advent of the automobile made it easy for residents to commute to work from outlying areas. Some of the first planned suburban neighborhoods were Shandon, Waverly, Eau Claire, Camp Fornance, Wales Garden and Hollywood.

By the dawn of the new century, the New South mentality was in full swing. Between 1901 and 1910, Columbia gained forty-one new banks, and in 1907 the "new" State House was finally completed. In 1913, the city annexed Shandon, Waverly and part of Eau Claire suburbs, and by 1920 Columbia had a population of 37,524. In 1903, Columbia progressed from a voluntary fire department to a paid one, and in 1907 the

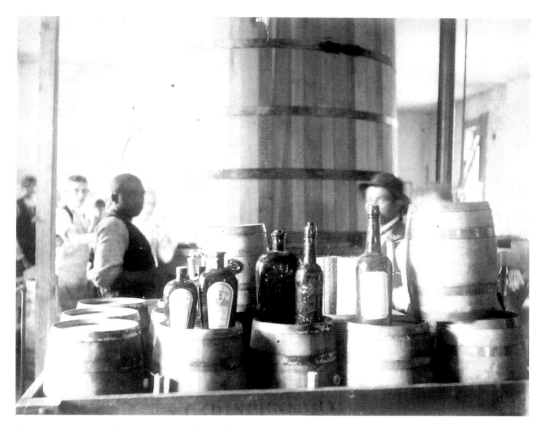

State dispensary bottlers, Gervais and Pulaski Streets. The state dispensary, also known as Governor Benjamin R. Tillman's Baby, was the state's effort to control the sale of alcoholic beverages in South Carolina. From 1895 to 1907, the State Dispensary Office in Columbia handled liquor distribution in South Carolina. *Cabinet photography by Reckling (photograph M-PL-C-V-2). Courtesy of South Carolinian Library, University of South Carolina, Columbia.*

city began paving Main Street. When the 1874 city hall burned, the police department was forced into temporary quarters until 1913, when the city gained a new police station and jail on Lincoln Street near the county jail.

The national outlook for the South changed in 1913 with Woodrow Wilson's election as president. Wilson, a Southerner, had spent his boyhood in Columbia. His father and uncle were professors at the Presbyterian Seminary. City fathers even invited Wilson to make his home in Columbia. Wilson's election spawned the Progressive years, which were marked by Prohibition, women's suffrage and voting reform.

Progressivism hit reality with the outbreak of World War I. The United States Army established Camp Jackson on the southeastern edge of Columbia. By 1918, Camp Jackson housed 3,302 officers and 45,402 enlisted men. The end of the Great War or the War to End All Wars in 1918 coincided with the deadly influenza epidemic. When the war ended, however, Camp Jackson continued its association with the United States Army until 1925, when it became a South Carolina National Guard facility.

Duck Mill, one of two cotton mills by the river, circa 1899. Columbia Mill, 301 Gervais Street, now home to the South Carolina State Museum, was known as the Duck Mill because it produced duck (canvas) cloth. When the mill opened in 1894, it was, according to the State Museum, the "first totally electric textile mill in the world." *Photograph by Harry M. King (photograph 12050.6). Courtesy of South Caroliniana Library, University of South Carolina, Columbia.*

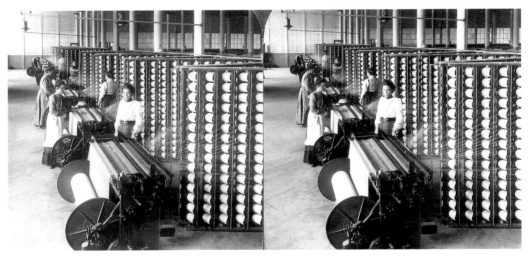

Warping Room, Olympia Cotton Mills, Columbia. Incorporated in 1900, Olympia Cotton Mills was the largest cotton mill in the world and by 1912 employed 850 people. The mill, one of the Parker Cotton Mill Company's plants, not only provided employment, but also housing, schools, churches, stores and libraries. *Stereograph by Underwood & Underwood (photograph 13021.2). Courtesy of South Caroliniana Library, University of South Carolina, Columbia.*

Snow scene, Will Hill to the right, Brigade Hospital (Camp Fornance) in the center and state fairground to the left, March 1899. Camp Fornance was a Spanish-American War army training facility located behind Elmwood Cemetery on a hill above the Broad River. Troops from Rhode Island trained there and found the eccentricities of Columbia weather (snow in March) unexpected. The state fairgrounds (1856–61, 1869–1903) extended from the Elmwood Avenue site of Logan School toward the Broad River. *Photograph by Harry M. King (photograph 12050.24). Courtesy of South Caroliniana Library, University of South Carolina, Columbia.*

The location of Camp Jackson impacted the city. Columbia grew toward Camp Jackson, and other suburbs developed at increasing distances from the city. The end of the First World War brought economic woes. The boom days of war supply ended abruptly, and there were few bright spots for Columbia during the 1920s. A new post office appeared in 1920, and in 1927 construction began on the dam project that would produce Lake Murray. The project employed 3,500 men and was a boon to the local economy. During the twenties, Columbia gained traffic lights and stop signs. Also, Columbia Hospital became a county concern.

In 1920, the Eighteenth Amendment brought Prohibition. Yet Columbia residents still had opportunities to drink. For example, in 1923, police uncovered a twenty-five-gallon tank of whiskey stored in the wall of a Gervais Street café.

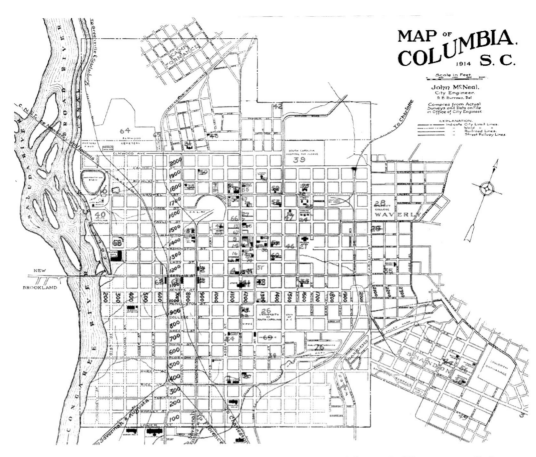

Map of Columbia, 1914. By 1912, Columbia had experienced "steady" growth. The corporate limits included four square miles (double its original size), and Columbia had a population of 31,319 with a number of suburban neighborhoods. The geographic and transportation hub of South Carolina, residents of the state could reach the capital in four and a half hours by rail. *Courtesy of South Carolina Department of Archives and History*.

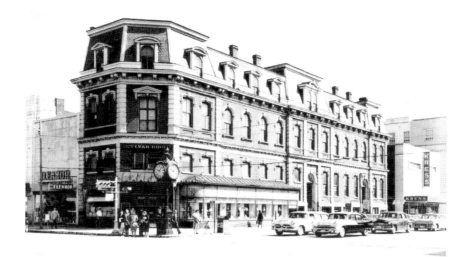

Central National Bank (Sylvan Building), 1500 Hampton Street, 1960. Built in 1871, the Sylvan Building on the corner of Hampton and Main Streets was originally the home of Central National Bank. In 1906, the Sylvan brothers purchased the building for their jewelry store. The clock was added in 1908. *Jack Boucher, photographer. HABS SC, 40-COLUM, 8-1. Courtesy of Library of Congress.*

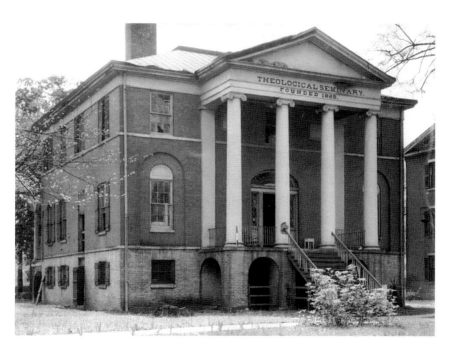

Ainsley Hall, Blanding Street, front (north) elevation, April 1924. Wealthy merchant Ainsley Hall built this house in 1823. He also built the house known as the Hampton Preston House. Unfortunately, he did not live to enjoy this gracefully designed Robert Mills home. At one point in its long history, the building housed the Presbyterian Theological Seminary, where President Woodrow Wilson's father and uncle Dr. James Woodrow were professors. In 1886, Winthrop University was founded here. *M.B. Paine, photographer. HABS SC, 40-COLUM, 3-1. Courtesy of Library of Congress.*

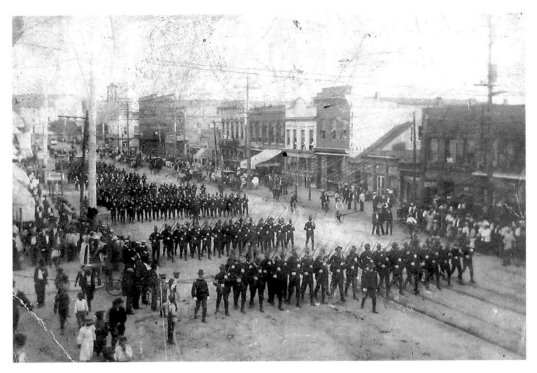

Camp Jackson soldiers on parade, Main Street, circa 1918. Camp Jackson troops participated in several Main Street parades in 1918. For example, on February 22, three thousand soldiers marched in honor of President George Washington's birthday. The big Liberty Bond parade was in September of that year. *(photograph 11622.14) Courtesy of South Caroliniana Library, University of South Carolina, Columbia.*

Depression and World War II

Black Thursday, October 24, 1929, triggered the great stock market collapse of 1929 and sent shock waves through the nation. As agriculture in the South was already depressed (by 1921 the boll weevil was infesting South Carolina cotton), the outlook for many residents in Columbia and South Carolina was bleak. Between 1922 and 1924, four Columbia banks closed their doors, but all was not doom and gloom. There were promising signs. By 1930, Columbia boasted 803 retail concerns and the Lake Murray dam was generating power. Owens Field, Columbia's municipal airport, also opened in 1930, and the Columbia Hotel at Gervais and Sumter Streets followed in 1931.

Yet as the thirties wore on, the economic outlook worsened. Small mills closed, unemployment rose, municipal pay was cut and the University of South Carolina paid its employees with scrip in 1932. Some Columbia residents lived in a shanty town near the town dump. Nevertheless, by 1933 and the election of Franklin D. Roosevelt as president, Columbia, the state and the South began to inch their way out of depression. As a seat of government, Columbia fared better during the Depression than other areas in South Carolina. In addition to housing state, county and municipal offices, Columbia also had the Veterans Hospital and the Farm Credit Administration's district

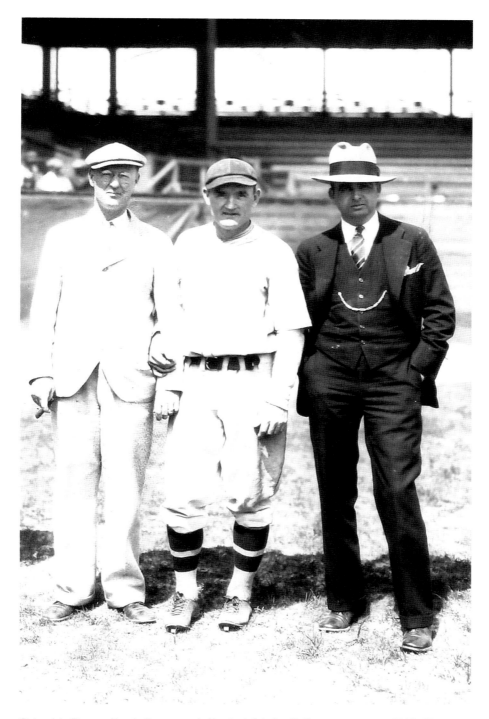

Columbia Comers Baseball personnel. On the left is Joe Kelly, team manager 1928–29, with Hulon and Louie L. Propst. For the 1930 census, Propst listed his occupation as "amusements" and his industry as "baseball." He was also involved with the operation of the Columbia Theatre. The Columbia Comers played in the South Atlantic League 1912, 1914–17, 1919–23 and 1925–30. In 1930, the team was an affiliate of the Pittsburgh Pirates. *(Samuel Latimer Papers, 22-969) Courtesy of South Caroliniana Library, University of South Carolina, Columbia.*

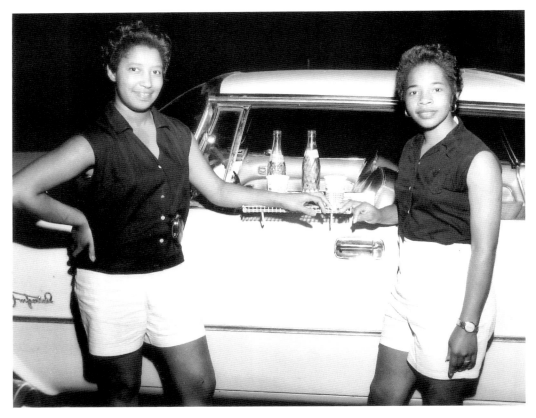

Drive-in waitresses, 1940s. The proliferation of automobiles sparked the heyday of drive-in dining. *(John H. McCray Papers) Courtesy of South Caroliniana Library, University of South Carolina, Columbia.*

headquarters. With the coming of the New Deal, Columbia was the state headquarters for the New Deal agencies. In addition, Columbia benefited from the New Deal work and relief programs. It gained a new $52,000 market shed on Assembly Street south of the 1924 facility. Federal funds also built the stadium and several institutions in Columbia received grants or loans. Federal programs increased opportunities for African Americans. Columbia used these gains to develop a diversified economy and by 1940 showed a population of 62,397.

World War II changed Columbia and accelerated population growth. Camp Jackson reverted to federal control and became Fort Jackson, a permanent military installation. Fort expansion and construction and increased numbers of servicemen not only added jobs and money to the Columbia economy, but also strained services. Housing grew increasingly tight and expensive. In addition, soldiers needed recreational outlets. In an effort to provide "wholesome" entertainment, an African American USO opened on Washington Street and a USO for white soldiers at Laurel and Assembly Streets on Arsenal Hill.

The attack on Pearl Harbor accelerated war preparations, troop training and war industries. Factories operated around the clock and the value of agricultural products rose.

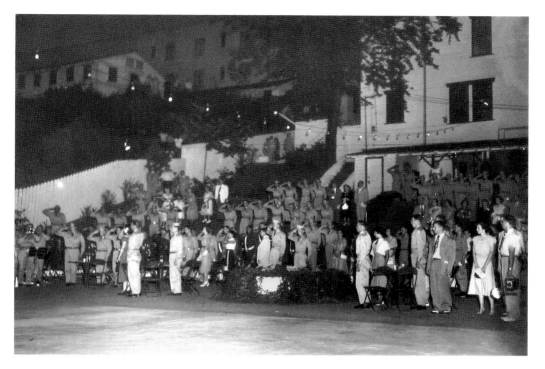

An army band performance behind the USO at Laurel and Assembly Streets, circa 1940s. With war on the horizon, Camp Jackson was reactivated and Fort Jackson became an active army training base. An estimated half a million troops did duty at Fort Jackson during World War II, and over two million servicemen visited Columbia's USO. *(photograph 10352.6) Courtesy of South Caroliniana Library, University of South Carolina, Columbia.*

During World War II, Fort Jackson trained half a million United States servicemen. Peace came, and Columbia jubilantly celebrated the Armistice (V-J Day) on August 14, 1945.

Peace also brought challenges. Columbia needed to repair neglected infrastructures and absorb returning GIs into the workforce. By 1950, only half the streets were paved and automobile traffic was on the increase. Fort Jackson, thanks to the Korean conflict, stayed as a permanent army training center and a major economic force in the Columbia and Richland County economy.

A New Day

The fifties and sixties changed the face of Columbia with urban renewal, integration and an increasing population shift to the suburbs. Columbia developed new parks and other amenities and spent millions on several new streetscaping projects on Main Street. In 1951, the National Municipal Association named Columbia an "All-American City."

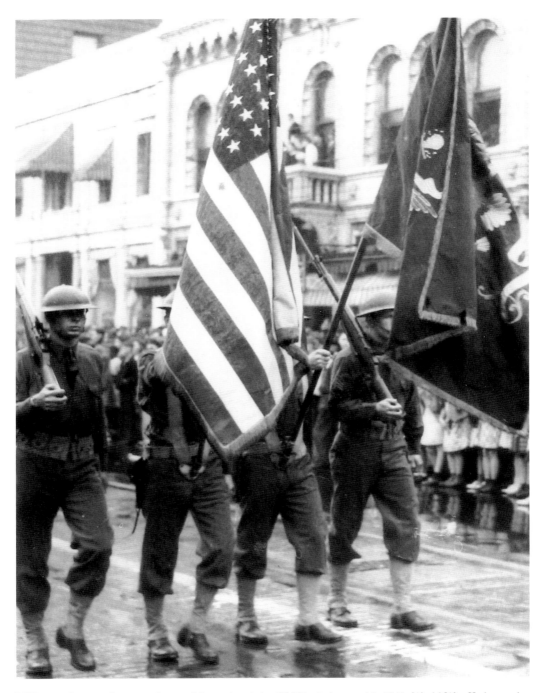

Military color guard on parade, possibly on Armistice (V-J Day), August 14, 1945. World War II changed Columbia. Thousands of soldiers trained at Fort Jackson, socialized and spent money in Columbia. The reactivated Fort Jackson did not close when the war ended, and in 1958 became a United States Army Training Center. Fort Jackson continues to impact the economy of Columbia and Richland County. *(Samuel Latimer Papers, 22-970) Courtesy of South Caroliniana Library, University of South Carolina, Columbia.*

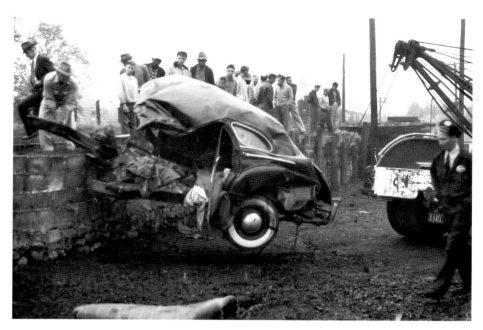

A train/car wreck at the corner of College Drive, 1948. By the 1890s, Columbia was a major railroad hub. Given the number of rails that crossed the city, the post–World War II automotive boom increased the risk of train/car accidents. *Jimmy Williams, photographer (photograph M-PL-C-B-4). Courtesy of South Caroliniana Library, University of South Carolina.*

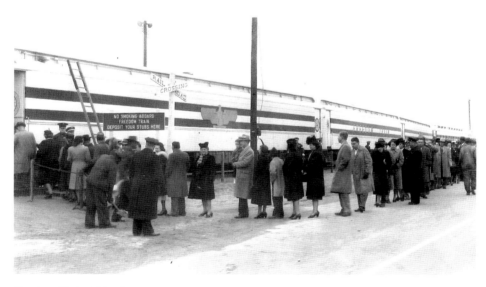

Freedom Train, 1947. In 1947, the American Heritage Foundation sponsored a Freedom Train that exhibited copies of historic American documents. The train visited three hundred communities in all of the then-forty-eight states. Among the documents on exhibit were Thomas Jefferson's draft of the Declaration of Independence, the Bill of Rights, George Washington's copy of the United States Constitution and the Iwo Jima flag. Supported by the United States attorney general, the American Heritage Program's goal was to increase citizen participation in government. On December 11, 1947 the Freedom Train visited Columbia, South Carolina. *(Samuel Latimer Papers, 22-968) Courtesy of South Caroliniana Library, University of South Carolina, Columbia.*

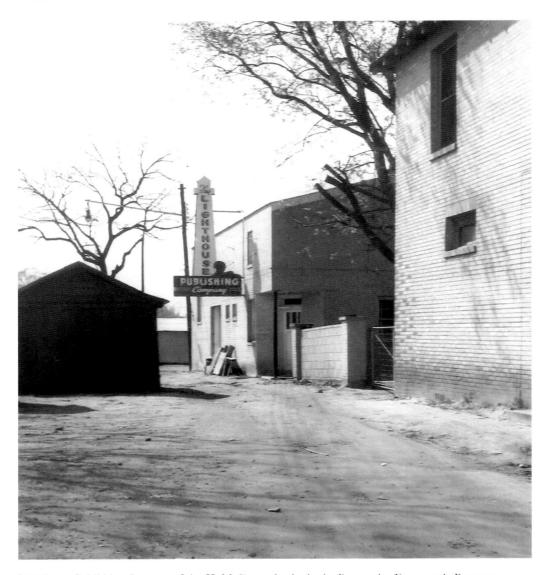

Lighthouse Publishing Company. John H. McCray, a leader in the Progressive Democratic Party, was also the editor and publisher of the *Lighthouse and Informer*. He moved the newspaper from Charleston to Columbia in 1941, and the paper ceased publication in 1954. *(John H. McCray Papers) Courtesy of South Caroliniana Library, University of South Carolina, Columbia.*

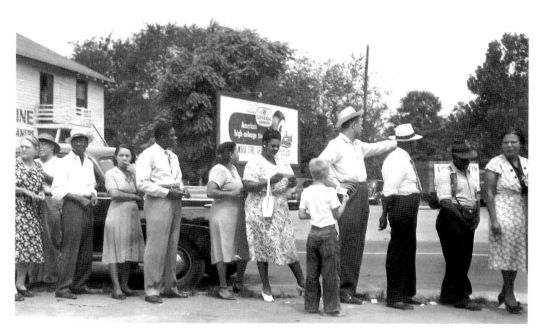

Primary election, 1948. Voters in line to vote in the Democratic primary included Mrs. Juliette Gilliam standing in the middle and William Gilliam, the second person behind her. Due to the efforts of John McCray, a leader of the Progressive Democrats, in 1948, African Americans could vote in the previously all-white primary. *(John H. McCray Papers) Courtesy of South Caroliniana Library, University of South Carolina, Columbia.*

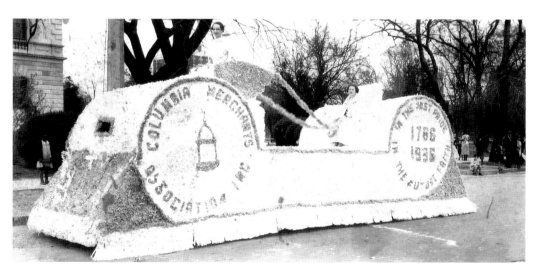

The Columbia Merchants Association, Inc., float in the sesquicentennial parade, 1936. Founded by legislative act in 1786, Columbia celebrated its 150th anniversary with parades, publications and the opening of Sesquicentennial State Park. The Columbia Merchants Association, Inc., incorporated December 7, 1929, merged with the Columbia Chamber of Commerce on March 2, 1955. *(Samuel Latimer Papers, 22-968) Courtesy of South Caroliniana Library, University of South Carolina, Columbia.*

Robert Mills House, Blanding Street, circa 1940. Designed by the American-trained architect Robert Mills for Columbia resident Ainsley Hall, the house was named a National Historic Landmark in 1973. Mills (1781–1855) was a prolific designer of churches, courthouses and other public structures. As an architect for the United States government, Mills designed the Washington Monument. At various times, the house was home to the Columbia [Presbyterian] Theological Seminary and Columbia Bible College. President Woodrow Wilson's father was a member of the seminary's faculty. Other Presbyterian luminaries included Dr. J.H. Thornwell, a renowned nineteenth-century theologian, and Dr. George Howe, who wrote a history of the Presbyterian denomination in South Carolina. *C.O. Greene, photographer. HABS SC,40-COLUM,2B-2. Courtesy of Library of Congress.*

The capitol complex grew to encompass four blocks and Main and Senate Streets ceased to be through streets. Gervais Street became the main east–west artery. While South Carolina governmental buildings have proliferated in downtown Columbia, no single institution has altered the face of Columbia as much as the University of South Carolina. Beginning at the end of the Depression, university presidents used federal funds to construct new buildings and exploited urban renewal to clear blocks south of Blossom between Pickens and Main for expansion. Both state and university demolished houses and buildings for parking.

A major change in the late twentieth century was the revitalization of the Vista area near the Congaree River. The former warehouse district now houses restaurants, hotels and shopping. Residential development is also underway. The Convention Center and the University of South Carolina's new baseball park are part of the redevelopment of that historic area. The closing of CCI (the Central Correctional Institution) along the Congaree opened up prime real estate for development. Citizens can also enjoy Riverfront Park, which runs along the end of the old canal.

Scene on the Columbia Canal, 1905. Completed in 1824, the Columbia Canal linked upstate commerce with the port city of Charleston. It was the most profitable of South Carolina's canals. The coming of the railroads diminished the importance of the canal for transportation. During the Civil War, the Confederate government leased the canal to power its powder works. By 1900, the canal was a vital source of electricity for the city of Columbia and local industries. Art Work of Columbia, *part 9. Courtesy of South Caroliniana Library, University of South Carolina, Columbia.*

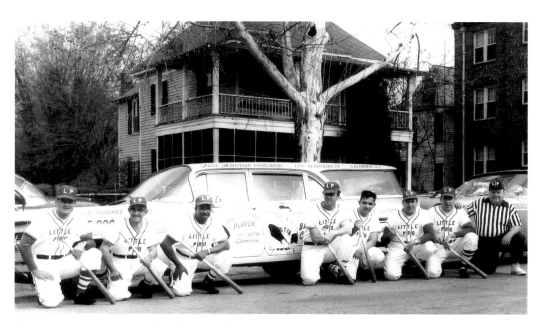

Little Pro Baseball Team, 1960s. This Little Pro team apparently was a barnstorming team organized by Dick Groat, a Duke basketball all-star and short stop for the World Champion Pittsburgh Pirates in 1960. The station wagon advertises the First American Corporation, Henderson Street, Columbia, and the "Most Valuable Player, 1960 Batting Champion, American League." Pete Runnells of the Boston Red Sox was the American League Batting Champion for 1960. That same year, Groat was the National League Batting Champion. *Photograph by Kent Studio (John H. McCray Papers). Courtesy of the South Caroliniana Library, University of South Carolina, Columbia.*

In the twenty-first century, Columbia is still a transportation hub. It is the center of an extensive state highway network and is connected to three interstate highways. In general, one can reach Columbia from any point in South Carolina in less than three hours. Columbia has a thriving art community, the flagship state university and a resilient economy. But as Columbia Mayor Hampton Gibbes noted in 1911, "There is still room for improvement."

LOST COLUMBIA OF 1865

By 1864, Columbia was a city in trouble. The war years had strained and overburdened the city's resources. Refugees from the Carolina coast and other Southern cities doubled the population, and food and lodging were increasingly expensive and in short supply. Residents were uncertain of the future, and neither civil nor military leaders apparently had a plan to defend the city. By December 1864, the city's gaslights no longer worked, and it was not safe to walk the streets after dark. Robbery and murder were on the increase. Thieves had even robbed the home of Major General Wade Hampton. The city was inadequately policed, and illegal alcohol was readily available. Columbia's red-light district called parts of Gervais Street home. There was an active black market and war profiteering.

Residents scourged, scrimped, substituted and celebrated when smuggled goods were available at the Importing & Exporting Company of South Carolina. Those who could not afford high prices or who faced limited resources made do. Ersatz—the use of substitutes—was a science. Individuals made their own soap, wove their own cloth and attempted to reclaim salt. According to J.F. Williams, there were many substitutes for coffee—"parched sweet potatoes, rye, wheat, okra seed, corn, peanuts…but rye was the most popular." Sorghum syrup was the only sweet available.

Columbia was a busy place and in general was somewhat removed from the war. Mary Boykin Chesnut wrote of an active social life and fine dining in Columbia. Conscription and relief efforts had their headquarters in Columbia. A hospital occupied South Carolina College buildings, and a chemical laboratory produced alcohol and other needed supplies at the old fairgrounds on Elmwood (near the site of Logan School). Plants produced sabers, ammunition, buttons, socks and matches. Joseph LeConte operated the Niter Bureau needed for gunpowder. The Saluda factory across the river produced cloth for Confederate uniforms.

Columbia was well connected by rail with other parts of South Carolina. The South Carolina Railroad depot, also the station for the Greenville and Columbia Railroad, stood on Gervais Street between the capitol and the river. The station for the Charlotte line was in the eastern part of Columbia.

Fire was an ever-present threat, so Columbia had four fire companies located around the city. In January 1864, fire destroyed a cotton warehouse on Lady Street, and in July of that year there was another cotton warehouse fire in Cotton Town. Cotton was

flammable and by the end of 1864, there were bales of cotton stored on Richardson (Main) from Richland to Laurel Streets; at the corner of Blanding and Richardson; and on Richardson between Washington and Lady Streets.

Benefits and bazaars were a part of Columbia's social scene. On January 17, 1865, a three-day relief bazaar offered unheard of treats—hams, turkeys, oysters and cakes. Each of the Southern states had a table. The event raised over $24,000 for the Wayside Hospital. Yet the magnificence of its larder contrasted sharply with the lives of many Columbia residents.

On February 16, two prongs of the Union army met on the banks of the Congaree. After a strategy session, one group moved toward Winnsboro to disrupt transportation lines and the other prepared to occupy Columbia. By this time, residents of Columbia were panicked, with evacuation efforts in full swing. The rail stations were jammed and confusion reigned. Fearing that Union troops would cut the rail line to Greenville, trains only left from the Charlotte station.

Some Confederate officials attempted to evacuate their equipment. The women from the Treasury Department safely exited the threatened city. William R. Huntt and other state officials saved the precious archives in their custody. Some took to the roads in wagons and carriages. Others milled around in disbelief.

As the Congaree River was swollen with rain, Union troops instead crossed the Saluda and Broad Rivers to reach Columbia. Confederates had burned the Saluda bridge, so Union forces erected a pontoon bridge. Across the Saluda, Union troops faced Confederate opposition that fired the Broad River bridge as they retreated. Constructing another pontoon bridge, by 10:00 a.m. on the morning of February 17, Colonel George Stone of the Twenty-fifth Iowa Infantry, commander of the Third Brigade, met Mayor Thomas Goodwyn and three aldermen who surrendered the city.

Citizens greeted the troops with gifts of liquor. Inebriated soldiers then became a factor in the destruction that followed. As was their custom, Union forces deployed a prevost guard and sent the remaining soldiers to camp beyond the city limits. This move left thousands of under-employed men on the loose. While descriptions of actual events vary, it is clear that some fires were set deliberately—for example, the old State House and the homes of Dr. Robert W. Gibbes and Wade Hampton—while others were perhaps the result of drunken soldiers looting homes and businesses. Several fires broke out on Richardson (Main) Street, and soldiers interfered with the fire companies' efforts to contain them. In addition, a stiff wind fanned the flames downtown so that Richardson Street and several blocks to the west bore the brunt of the destruction.

Dawn on February 18 brought vistas of smoldering fires, lonely chimneys and displaced men, women and children. Some sought refuge at the State Hospital; others sat in the streets with what few belongings they had saved. In addition to the old State House, fire destroyed city hall and jail, Richland County Courthouse and jail, the convent, Columbia's business district and a number of churches. There were bright spots—the South Carolina College campus was unscathed and many residential areas suffered little damage.

Columbia was rebuilt, but the Columbia of 1883 was not the one that had faced Sherman's troops that cold February of 1865.

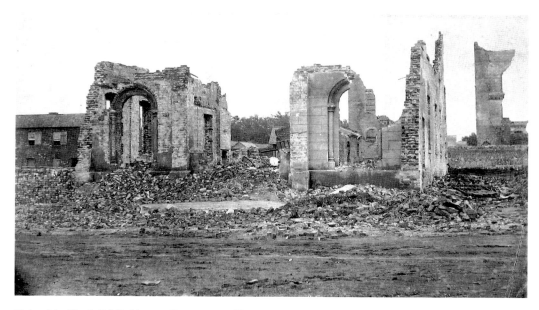

Columbia City Jail, Washington Street, 1865. The three-story jail stood on the northwest corner of Richardson (Main) and Washington Streets, adjacent to city hall and the police guard house. A jailed Federal prisoner made sketches of the jail and environs that were published in *Harper's Weekly* in 1864. *Carte-de-visite by Richard Wearn (photograph Wearn 1). Courtesy of South Caroliniana Library, University of South Carolina, Columbia.*

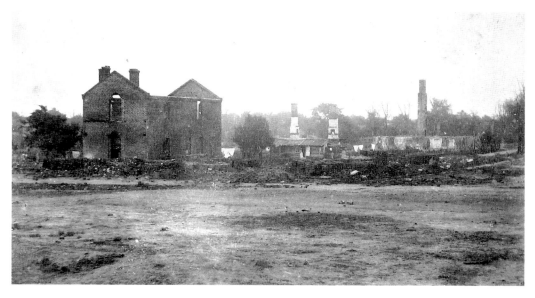

Corner of Main and Laurel Streets, Columbia, 1865. The 1860 city directory listed several businesses operating at this intersection, including the City Hotel and Boyne & Sprowl, marble workers. Today, the corner of Main and Laurel Streets is home to city hall and the Jefferson Building on the site of the old Jefferson Hotel. Richard Wearn, the photographer, was a native of the Isle of Man. *Carte-de-visite by Richard Wearn (photograph Wearn 2). Courtesy of South Caroliniana Library, University of South Carolina, Columbia.*

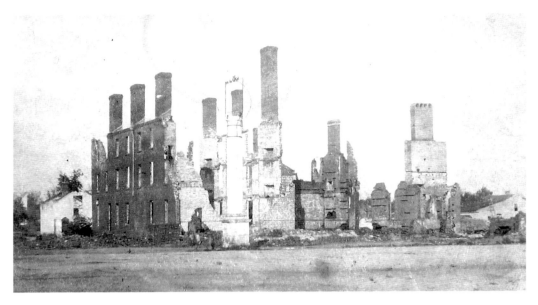

Catholic convent, Blanding and Main Streets, 1865. In 1834, Bishop John England of Charleston brought the Ursuline nuns to Charleston from Black Rock, Ireland. In 1858, Bishop P.N. Lynch invited the nuns to settle in Columbia. The nuns purchased this building, once operated as a hotel, and opened an academy. After its destruction in 1865, the nuns reopened the academy at Valle Crucis, an estate three miles from Columbia. In 1890, the convent and school found a new home at 1505 Assembly Street. In time, the former site of the convent became the site of Tapp's Department Store. *Carte de visit by Richard Wearn (photograph Wearn 4). Courtesy of South Caroliniana Library, University of South Carolina, Columbia.*

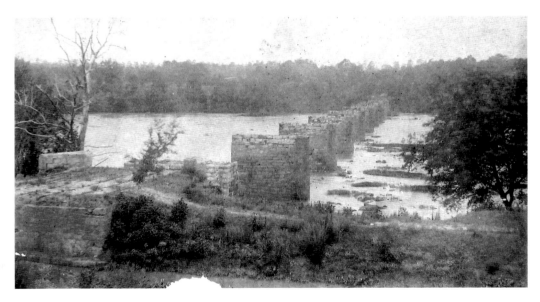

Bridge over the Congaree River, 1865. The Columbia Bridge Company built the first bridge over the Congaree at Gervais Street. The bridge operated from 1827 until its destruction in 1865 in an attempt to delay the entry of Union troops into Columbia. The old bridge piers can be seen north of the current Gervais Street Bridge. Rebuilt in 1870, the replacement bridge was the only one across the Congaree until 1953. *Carte-de-visite by Richard Wearn (photograph Wearn 6). Courtesy of South Caroliniana Library, University of South Carolina, Columbia.*

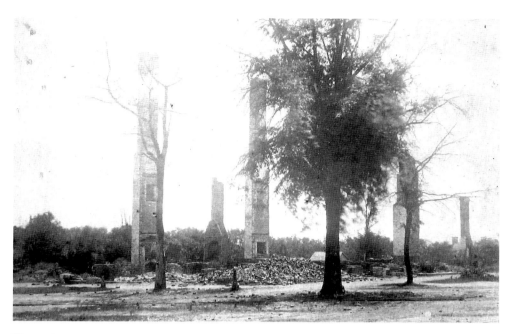

Hunt's (Boarding) House, 1865. This was possibly the home/boardinghouse of Edward Hunt in the 2000 block of Richardson (Main) Street. In 1860, Hunt, a fifty-five-year-old Englishman, listed his occupation as gasfitter. *Carte-de-visite by Richard Wearn (photograph Wearn 10). Courtesy of South Caroliniana Library, University of South Carolina, Columbia.*

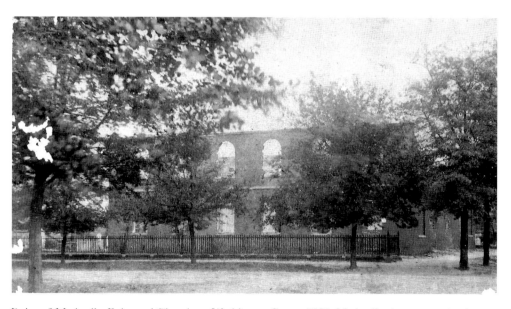

Ruins of Methodist Episcopal Church on Washington Street, 1865. Methodists began meeting in the new capital in 1787. They erected their first church building in 1804. On July 22, 1832, the congregation dedicated its second sanctuary, the one that burned in February 1865. Edwin Scott attended the final service in the church building on Sunday, February 12, and noted that the minister preached an "excellent sermon." Using salvaged bricks, members constructed the third sanctuary on this site in 1866. *Carte-de-visite by Richard Wearn (photograph Wearn 12). Courtesy of South Caroliniana Library, University of South Carolina, Columbia.*

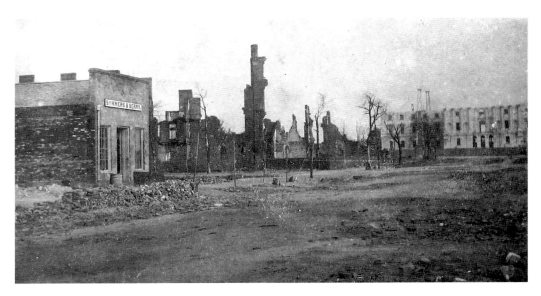

View of Main Street with the State House in the background, 1865. George Symmer, a native of Scotland and a merchant, may have been the Symmer of Symmer & Berry, the store seen on the left. Berry could have been the W.H. Berry who in 1891 advertised that he had been in business on Main Street since 1843. Richard Wearn, the photographer, had moved to Columbia from Newberry in 1859 and had his studio at 170 Richardson (Main) Street near its intersection with Plain (Hampton). After the Civil War, he reopened his studio. *Carte-de-visite by Richard Wearn (photograph Wearns 13). Courtesy of South Caroliniana Library, University of South Carolina, Columbia.*

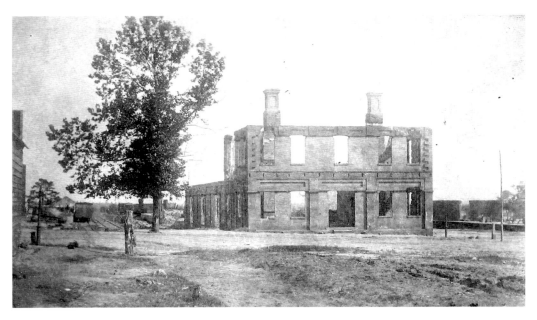

Offices of the South Carolina Railroad, 800 Gervais Street, 1865. Originally constructed circa 1845, the South Carolina Railroad depot was gutted by fire in 1865 and rebuilt circa 1870. J.F. Williams noted that a torch ignited government powder stored there and produced a deadly explosion the morning of February 17, 1865. *Carte-de-visite by Richard Wearn, 1865 (photograph Wearn 14). Courtesy of South Caroliniana Library, University of South Carolina, Columbia.*

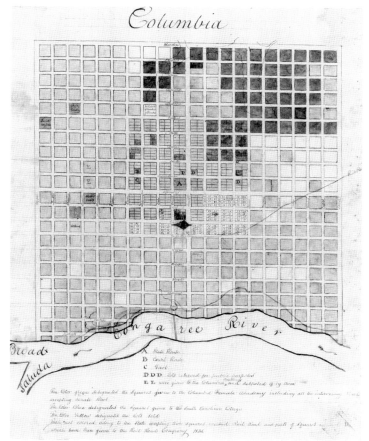

1. *Right:* Plat of Columbia, circa 1848. The enabling legislation authorized commissioners to purchase and lay out a two-mile-square tract of land with streets at least 60 feet wide and two 160-foot avenues at right angles. As a planned city, the commissioners reserved lots for government, education and other civic endeavors. *Courtesy of South Carolina Department of Archives and History.*

2. *Below:* A rose, the South Carolina state flower, circa 1917. On February 1, 1924, the South Carolina General Assembly adopted the yellow jasmine as the official state flower. *Courtesy of William E. Benton.*

3. Greetings from Columbia, South Carolina. This postcard highlights Columbia's attractions, including the State House ("C"), Main Street ("M"), World War Memorial Building ("A"), Arsenal Hill, the governor's mansion ("S") and the present Supreme Court Building ("C"). *Central News Company, Columbia. Curteich-Chicago "C.T. Art Colortone" Post Card. Courtesy of William E. Benton.*

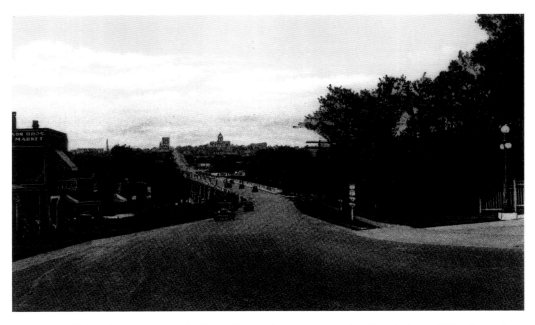

4. Congaree Bridge looking toward the State House. Construction on the Gervais Street Bridge began in 1926 and the bridge opened in 1928. From 1928 until 1959, this bridge was the only Columbia bridge that crossed the Congaree River. *Gayden Brothers, Charleston and Columbia, South Carolina. Courtesy of William E. Benton.*

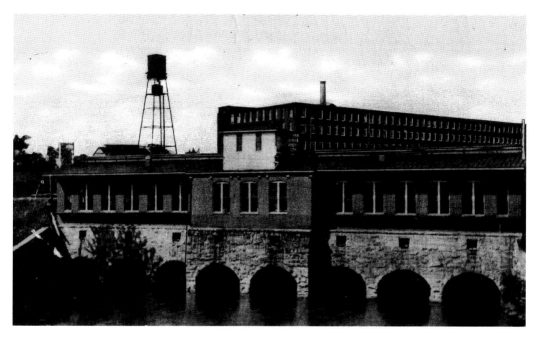

5. Electric powerhouse and Columbia Duck Mill. In 1896, the Columbia Hydro Plant replaced an 1894 facility upstream. The former facility had not been able to generate sufficient electricity to power the Duck Mill and other manufacturing enterprises and also power city lights and trolleys for Columbia. The power plant, owned by the City of Columbia and operated by South Carolina Electric and Gas Company, still operates with the original turbines. *F.W. Kirby & Co. Courtesy of William E. Benton.*

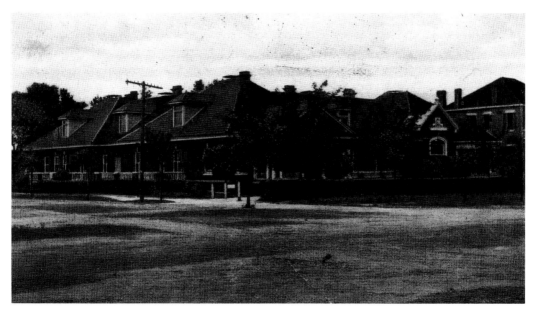

6. Columbia Hospital. On motion of Mrs. David R. Flenniken, the United King's Daughters of Columbia organized the Columbia Hospital Association on May 24, 1892. Chartered on September 17, 1892, Columbia Hospital formally opened on November 1, 1893. In 1904, the hospital added an operating facility and private rooms. *J.S. Pinkussohn Cigar Co. Courtesy of William E. Benton.*

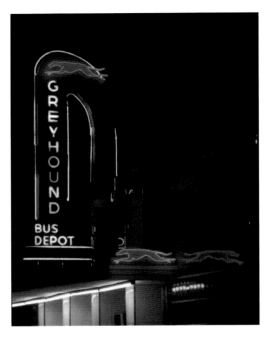

7. Neon sign, Greyhound Bus Station, 1200 Blanding Street, circa 1939. As the Good Roads movement in the early twentieth century brought increased urban access for rural South Carolinas, the need for reliable transport grew. Buses were the major transportation option for most South Carolinians who lived in rural areas or small towns not served by the railroads. George D. Brown was the architect for the Greyhound Bus Depot, built between 1938 and 1939. *HABS SC, 40-COLUM, 16 - sc 12. Courtesy of Library of Congress.*

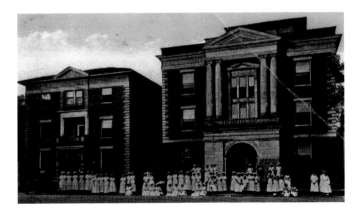

8. Baptist Hospital, Hampton Street, circa 1936. The South Carolina State Baptist Convention purchased the former Knowlton Infirmary, and on September 1, 1914, the South Carolina Baptist Hospital opened its doors. By 1936, Baptist Hospital had 109 beds and a nursing school. *C.A. Stead, New Orleans, Louisiana. Courtesy of William E. Benton.*

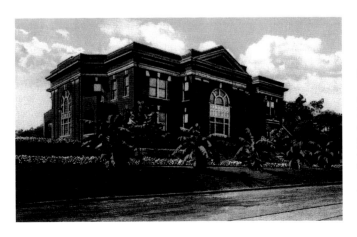

9. Tabernacle Baptist Church, 1517 Gregg Street (corner of Gregg and Taylor Streets). Established by First Baptist Church of Columbia, the mission church outgrew its facilities at 1928 Blanding Street. Organized as an independent congregation in April 1911, Reverend Mr. A.B. Kennedy was the first pastor. *Southern Post Card Company, Ashville, North Carolina. Courtesy of William E. Benton.*

10. The Broad River near the point where Sherman's army crossed on pontoon bridge to enter Columbia. Confederate troops burned this and other bridges to slow Sherman's advance on the city. *Souvenir Post Card Co., New York and Berlin. Courtesy of William E. Benton.*

11. Main Street showing the state capitol. In 1893, electric streetcars replaced horse-drawn cars. A double track ran up Main Street from the State House to the former post office on Laurel Street. The flag-bearing buildings are, on the left, the Palmetto Building; center, the State House; and on the right, city hall and opera house. *Southern Post Card Company, Asheville, North Carolina. Courtesy of William E. Benton.*

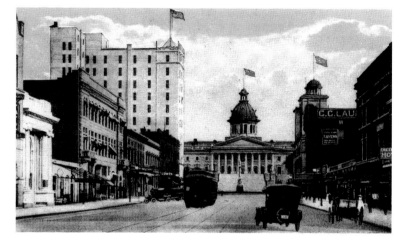

12. State capitol with a Confederate flag formed by children on the steps. The newspaper reported on May 15, 1906, that hundreds of girls dressed in red, white and blue formed the Stars and Bars on the State House steps at the conclusion of the annual Confederate veterans' parade. *Southern Post Card Company, Asheville, North Carolina. Courtesy of William E. Benton.*

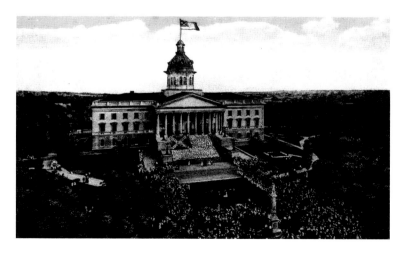

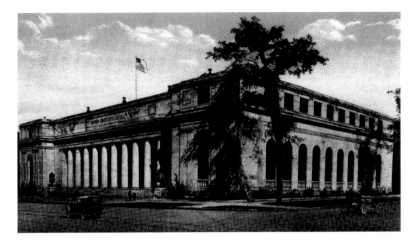

13. United States Post Office, circa 1924. Completed in 1874, the old post office building now houses Columbia city offices. *C. T. American Art. Southern Post Card Company, Asheville, North Carolina. Courtesy of William E. Benton.*

14. Lobby of the Jefferson Hotel, at the corner of Main and Laurel Streets, circa 1915. John J. Cain built the six-story steel-framed hotel in 1912. The Jefferson, frequented by South Carolina legislators, was a favorite venue for conventions and benefits. In the 1960s, C&S Bank's Jefferson Square Complex replaced the hotel. *Acmegraph Co., Chicago. Courtesy of William E. Benton.*

15. Sumter Street, looking north from Green Street, circa 1914. The University of South Carolina Horseshoe is on the right. Today, businesses and Wardlaw College (1930) have replaced these early twentieth-century faculty homes. *Courtesy of William E. Benton.*

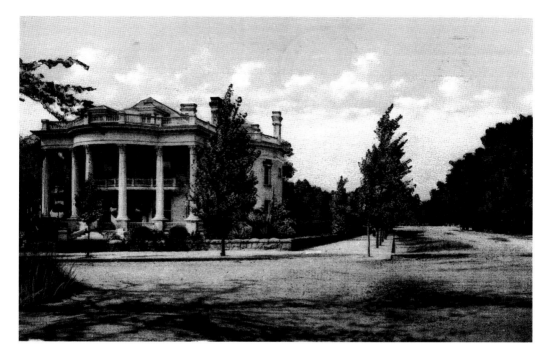

16. Bull and Pendleton [Senate] Streets, circa 1912. The house located at 1429 Senate Street was the home of George Baker. The South Carolina Department of Education (Rutledge Building) now occupies the site. *F.M. Kirby & Co. Courtesy of William E. Benton.*

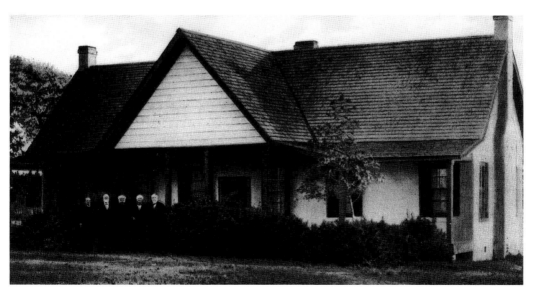

17. Southern Cross, home of Wade Hampton. After his plantation home Millwood was burned in 1865, Wade Hampton, Civil War hero and former governor of South Carolina, built this bungalow. He lived in Southern Cross until fire destroyed the house and his library in 1899. *Souvenir Post Card Co., New York and Berlin. Courtesy of William E. Benton.*

18. Gervais Street, circa 1907. This card shows a quiet, tree-lined Gervais Street. Streetcar tracks are evident on the right. The streetcar line reached Gervais Street in 1893 and in 1896 the line was extended to connect Gervais, Harden and Main Streets with Shandon. *Wm. H. Cobb Co. Courtesy of William E. Benton.*

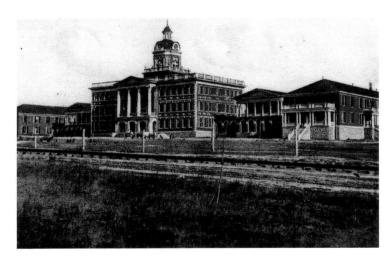

19. Columbia College. This postcard depicts Old Main, built in 1910 and the center of campus life until it burned on February 12, 1964. Founded in the 1850s, the school outgrew its original location on the 1600 block of Hampton Street and in 1905 moved to a forty-acre tract north of Columbia donated by Frederick Hyatt. *The American News Company, New York. Courtesy of William E. Benton.*

20. Horseshoe, University of South Carolina. The historic Horseshoe is the heart of the university's campus. With the exception of McKissick Library, all the buildings around the Horseshoe were originally built or rebuilt before the Civil War. South Carolina's flagship university evolved from South Carolina College, which was established by the South Carolina legislature in 1801. *Published in Germany. Courtesy of William E. Benton.*

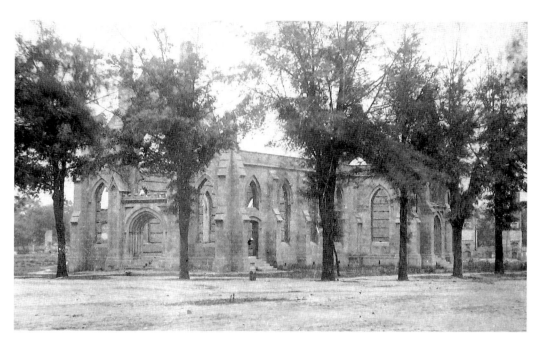

Christ Episcopal Church, Blanding and Marion Streets, 1865. Christ Episcopal, the largest Episcopal church in Columbia at the time, was one of several churches that burned in February 1865. In 1860, Reverend Mr. J. Maxwell Pringle was the minister. *Carte-de-visite by Richard Wearn (photograph Wearn 16). Courtesy of South Caroliniana Library, University of South Carolina, Columbia.*

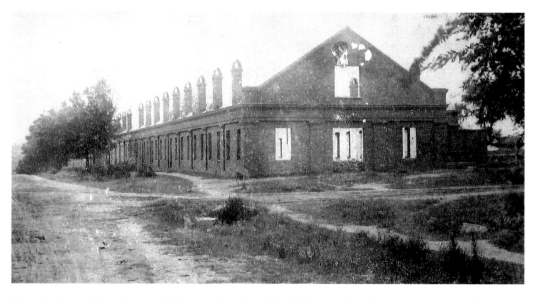

Evans & Cogswell printing establishment, Gervais at Pulaski Streets, 1865. On August 29, 1863, Evans & Cogswell, a Charleston printing firm, bought three and a half acres in the 500 block of Gervais Street. In 1861, Evans & Cogswell became one of the leading producers of Confederate currency. By February 1864, the firm had moved its operations from Charleston, which was under heavy bombardment, to Columbia. *Carte-de-visite by Richard Wearn (photograph Wearn 19). Courtesy of South Caroliniana Library, University of South Carolina, Columbia.*

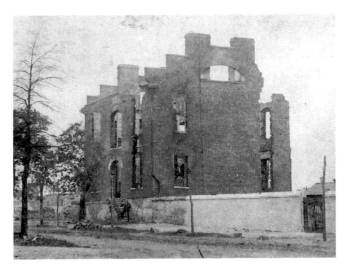

Residence of Dr. Robert W. Gibbes, Sumter and Plain (Hampton) Streets, 1865. Gibbes (1809–1866), in addition to being a physician, was also a newspaper editor, cotton mill owner and professor at South Carolina College (University of South Carolina). Dr. Gibbes also compiled and published the multivolume *Documentary History of the American Revolution*. During the Civil War, he served as surgeon general of South Carolina. When Columbia burned on February 17, 1865, Gibbes lost his home, library, art and scientific collections. *Carte-de-visite by Richard Wearn, 1865 (photograph Wearn 11). Courtesy of South Caroliniana Library, University of South Carolina, Columbia.*

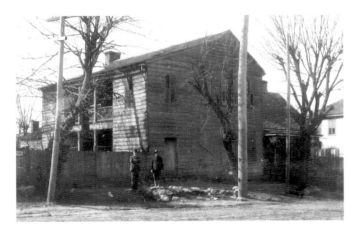

House on Main (Richardson) Street, one of the few not destroyed by fire in 1865, circa 1899. J.F. Williams stated that the only house on Main Street that survived the fire belonged to Alexander Riley, a thirty-five-year-old Irish merchant in 1860, and stood on the east side of the 1900 block. Reportedly the French consul, a refugee from Charleston, lived there and was flying the French flag time at the time of surrender. *Photograph by Harry M. King (photograph 12050.1). Courtesy of South Caroliniana Library, University of South Carolina, Columbia.*

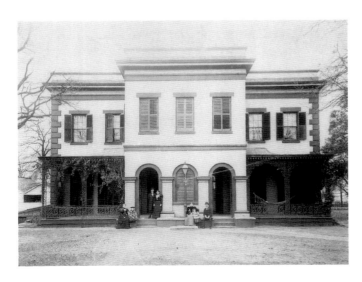

Governor's mansion, circa 1895. Governor John Gary Evans (1863–1942) and family stand in the doorway. Evans served as governor from 1894 to 1897. South Carolina did not have an official governor's mansion until 1868. The present mansion was the officer's quarters for Arsenal Academy, and was one of the few academy buildings to survive the burning of Columbia on February 17, 1865. *Photograph by the Empire View Company (photograph M-PL-C-H-24). Courtesy of South Caroliniana Library, University of South Carolina, Columbia.*

EVER-CHANGING MAIN STREET

The commissioners who laid out Columbia intended Assembly Street to be the town's business district. As usually happens, human beings had other ideas. So from their earliest days, businesses—stores, hotels, taverns, boardinghouses, livery stables and other support services—congregated along Richardson (Main) Street and the side streets that crossed it.

By 1860, Richardson was the business center of Columbia. In the 1850s, gaslights were added. Hotels, boardinghouses, blacksmith shops, department stores, taverns, restaurants and many other enterprises lined the street. After the fires of February 1865, Columbia's Main Street was in shambles. Some businesses, such as McKenzie's Confectionary and M.H. Berry, rebuilt. Newcomers filled the vacant lots with new shops.

Main Street owners prospered during the Reconstruction legislature and watched the hotly contested election of 1876. For a time, South Carolina had two governors (Wade Hampton, the Democratic candidate, and Daniel Chamberlain, the Republican candidate) and two Houses of Representatives. One met in the State House and the other (the Democratic one) in Carolina Hall. When national politics threw the election to Hampton, Main Street was the scene of rejoicing. South Carolina had been "redeemed"— white and African American Republicans no longer controlled state government.

In the 1880s, Main Street was unpaved. It was muddy when it rained and dusty and dry if there was no rain. The recently dedicated Confederate Monument stood in front of the habitable State House. In 1880, telephones came to Main Street and in 1881 the Carolina National Bank reorganized and financed the construction of several textile mills. Horse-drawn streetcars plied Main Street in 1882. By 1883, from the window of C.H. Baldwin's Main Street grocery, there was little evidence of the destruction of 1865.

In 1891, Columbia celebrated the centennial of the first meeting of the legislature in Columbia. Businesses along Main Street closed for two days. Decorated arches, each representing a different South Carolina county, adorned the street. Yet the celebration organizers shunned the newly elected populist governor, Benjamin R. Tillman, and asked Wade Hampton to deliver the main address.

With the Tillmanites and the Constitution of 1895, legal segregation came to Main Street and to South Carolina. Main Street also figured in the end of segregation on Main Street. In 1960, African Americans marched down Main Street and protested racial discrimination at Woolworth's lunch counter.

By 1900, electricity, rather than horses, powered Columbia's streetcars. In 1909, President William Howard Taft visited Columbia. A parade down Main Street honored his visit. Hundreds of people lined Main Street to see him. In 1907, Columbia began paving Main Street.

Main Street hosted many parades—Spanish-American War soldiers, soldiers from Camp Jackson during World War I and Fort Jackson during World War II, veterans' parades, Christmas parades and visiting dignitaries in motorcades traversed Main Street.

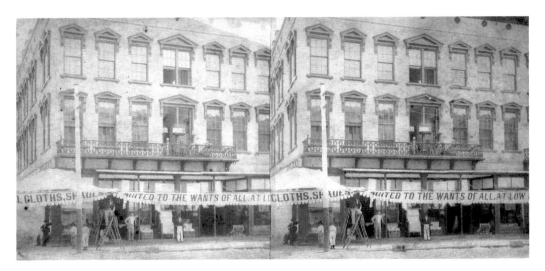

W.D. Love & Co., Richardson (Main Street), circa 1876, advertised: "Suited to the Wants of All, Low Prices." William D. Love, a native of County Donegal, Ireland, immigrated to New York and entered the mercantile business. In 1869, Love relocated to Columbia and operated W.D. Love & Co., a dry goods establishment. Love died in 1896 and was buried in the churchyard of First Presbyterian Church. *Stereograph by Wearn & Hix (photograph 3611). Courtesy of South Caroliniana Library, University of South Carolina, Columbia.*

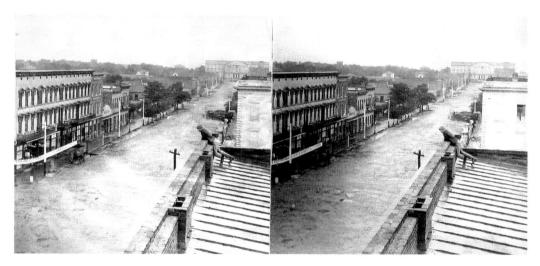

Main Street from top of "Art Gallery" looking toward the State House, circa 1876. Richard Wearn, who died in 1874, and W.P. Hix operated a studio in the Art Gallery at 124½ Richardson (later Main) Street between Plain (Hampton) and Washington Streets until 1880. W.D. Love's department store is on the left. *Stereograph by Wearn & Hix (photograph 12559.2). Courtesy of South Caroliniana Library, University of South Carolina, Columbia.*

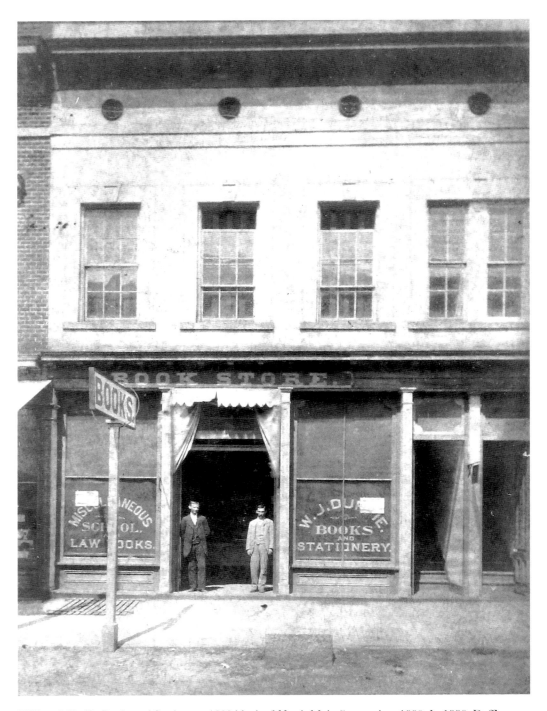

William J. Duffie Books and Stationery, 1500 block of North Main Street, circa 1880. In 1880, Duffie, a South Carolina–born merchant, lived with his family on Richland Street. His son, William K. Duffie, clerked in the store. In 1891, Duffie advised South Carolina teachers to teach history, particularly South Carolina history, and to use *Davidson's School History of South Carolina* in their classrooms. Duffie published the approved school text and asserted that the author's style "suits the school boy and school girl" and that the large type and short paragraphs made the book a success! *(photograph 9222.2) Courtesy of South Caroliniana Library, University of South Carolina, Columbia.*

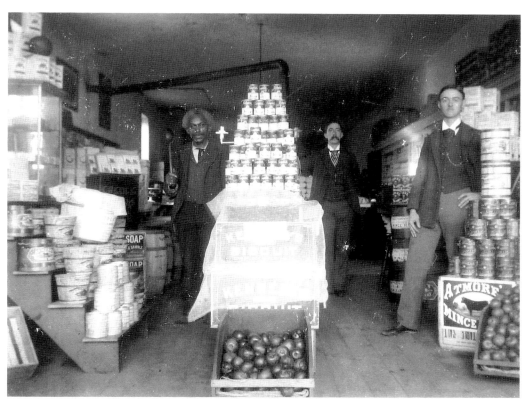

C.H. Baldwin and Son, Grocers, Main Street. Cyrus Hull Baldwin is in the center and Fritz Cronenberg is to his right, also in the doorway, June 1897. In 1900, Baldwin was a thirty-three-year-old grocer. In 1904, he advertised "real Smithfield hams direct from Virginia." He and his family lived on Washington Street. Born in South Carolina in 1866, his parents were natives of Connecticut. Baldwin died in Seneca, South Carolina, in 1906. *(photograph 9222.4) Courtesy of South Caroliniana Library, University of South Carolina, Columbia.*

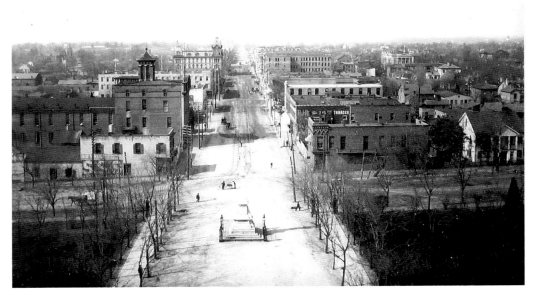

North Main Street from State House dome, circa 1899. On the left, in the distance, stands Columbia's second city hall on the corner of Washington and Main Streets. City hall burned in 1899. According to the 1898 Sanborn Fire Insurance Map, a grocery stood on the left corner of Gervais and Main Streets and the building with the cupola was the State Department of Agriculture. The buildings on the right in the first block included a drugstore, furniture store and steam laundry. Lining Main Street were several hotels, including the Grand Central, Columbia and Wright's. *Photograph by Harry M. King (photograph 12050.30). Courtesy of South Caroliniana Library, University of South Carolina, Columbia.*

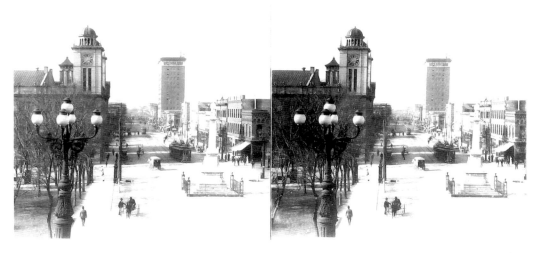

Main Street looking north from the State House. The Confederate monument, dedicated in 1879, stands in front of the State House. City hall/opera house is on the left and the Barringer Building, Columbia's first skyscraper, is on the right. The building with the distinctive cupola beyond city hall at one time housed the State Department of Agriculture. Streetcars traveled up and down the parallel sets of tracks on Main. *Stereograph by Keystone View Company (photograph 12670.12). Courtesy of South Caroliniana Library, University of South Carolina, Columbia.*

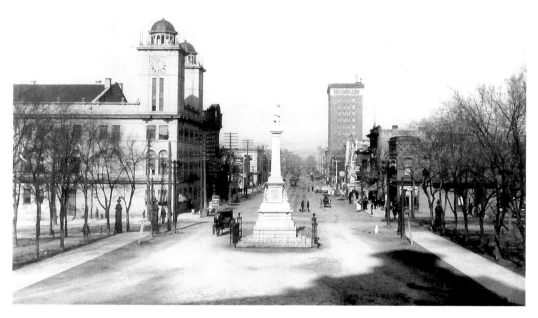

Main Street from the State House, 1905. City hall stands on the left and the high-rise Barringer Building on the right. The town clock was in the first tower of city hall, which shared space with a large theatre. The building on the right at the corner of Gervais and Main Streets housed the streetcar transfer station, a fruit stand and a barber. Art Work of Columbia, *part 1. Courtesy of South Caroliniana Library, University of South Carolina, Columbia.*

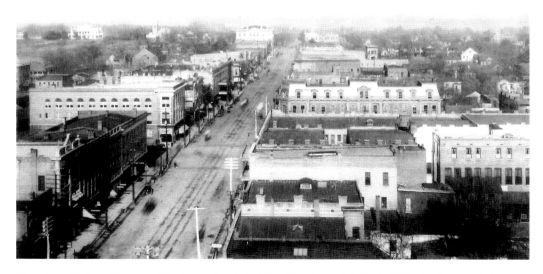

View from National Loan and Exchange Bank Building (Barringer Building), 1905. Looking north from Columbia's first skyscraper, one has a panoramic view of Columbia. The Sylvan Building is on the right and beyond it, on the left, the U.S. Post Office. On the far left is visible Laurel Hill, the palatial home of E.W. Robertson, president of the National Loan and Exchange Bank. Art Work of Columbia, *part 2. Courtesy of South Caroliniana Library, University of South Carolina, Columbia.*

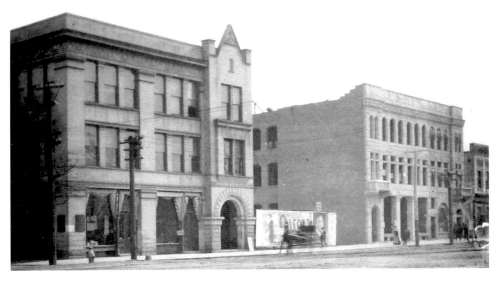

View on Main Street, 1905. By 1905, imposing structures, horse-drawn transportation and electric streetlights characterized much of Columbia's Main Street business district. Little evidence of the fire of 1865 remained. Art Work of Columbia, *part 9. Courtesy of South Caroliniana Library, University of South Carolina, Columbia.*

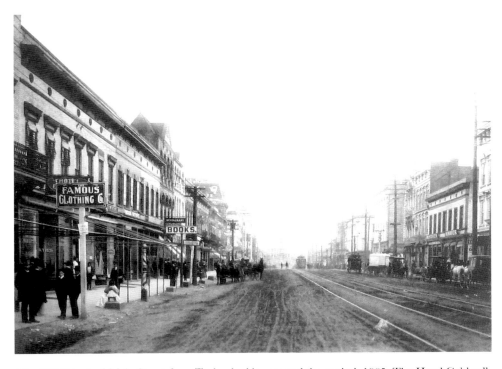

The 1500 block of Main Street from Taylor, looking toward the capitol, 1905. The Hotel Caldwell is on the left and the Columbia Hotel on the right-hand corner of Taylor and Main Streets. Midway down the block on the left is the former Canal Dime Savings Bank (Eckerd's) Building. Art Work of Columbia, *part 4. Courtesy of South Caroliniana Library, University of South Carolina, Columbia.*

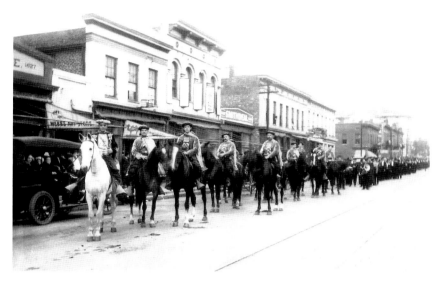

Parade on Main Street with horsemen and band, 1600 block of Main Street, looking north. In 1906, Walter L. Blanchard opened Columbia Photographic Studio in Columbia, which he operated until his death in 1939. *Columbia Photographic Studio (photograph 10006.1). Courtesy of South Caroliniana Library, University of South Carolina, Columbia.*

A steam-powered fire engine in front of the State House during Fire Prevention Week, 1934. From its earliest days, fire was a serious threat to Columbia's commercial and residential areas. From the 1930s into the 1960s, Columbia celebrated Fire Prevention Week with parades. *Sargeant Studio (photograph 8441.49). Courtesy of South Caroliniana Library, University of South Carolina, Columbia.*

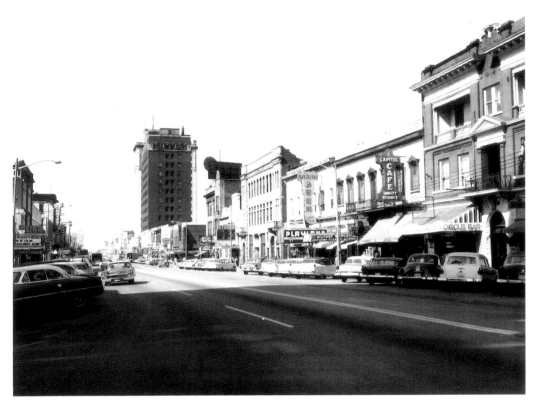

Main Street with Capitol Café, 1210–1214 Main Street. The Capitol Café building was completed by 1871. Beginning in 1913, the Capitol Café, a Columbia institution and meeting place for legislators, occupied the building until the Capitol Restaurant closed in 2002. *(Samuel Latimer Papers, 22-970) Courtesy of South Caroliniana Library, University of South Carolina, Columbia.*

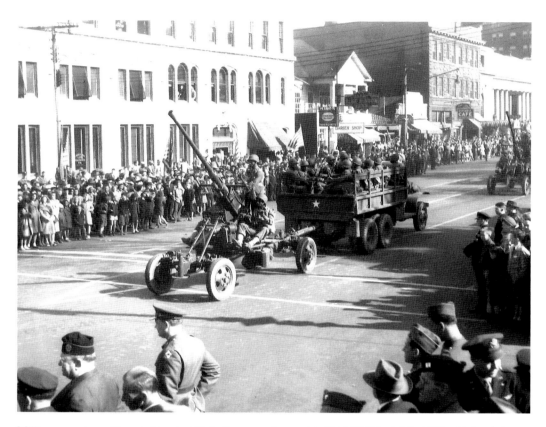

Military parade on Gervais Street at Main Street on August 14, 1945 (V-J Day), World War II Armistice. *(Samuel Latimer Papers, 22-973) Courtesy of South Caroliniana Library, University of South Carolina, Columbia.*

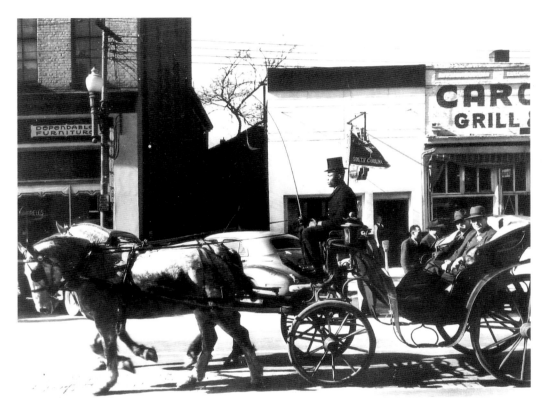

Governor's carriage on Gervais Street at the inauguration of Olin D. Johnston, 1943. This photograph captures Olin D. Johnston en route to his inauguration for his second term as governor of South Carolina. The Anderson County native had earlier served as governor from 1935 to 1939. Following his election to the United States Senate, Johnston resigned as governor on January 3, 1945. He served in the U.S. Senate from that date until his death in Columbia on April 18, 1965. *Photograph by Munn of Sargeant Studio (photograph 6752.9). Courtesy of South Caroliniana Library, University of South Carolina, Columbia.*

Eckerd modern drugstore, 1530 Main Street. W.B. Smith Whaley designed this building for the Canal Dime Savings Bank. Constructed between 1892 and 1895, the building later housed the Loan and Exchange Bank, State Bank & Trust Co. and the People's Bank of Columbia. Eckerd drugstore obtained the property in 1936. *Graycraft Card Co., Danville, Virginia. Courtesy of William E. Benton.*

Eckerd's modern 42½-foot soda fountain, 1530 Main Street. After Eckerd drugs acquired the former Canal Dime Savings Bank in 1936, the spectacular soda fountain was one of its alterations. *Graycraft Card Co., Danville, Virginia. Courtesy of William E. Benton.*

Greenwood High School marching band on Main Street. The band is passing the Palmetto and Barringer Buildings. *(Samuel Latimer Papers, 22-970) Courtesy of South Caroliniana Library, University of South Carolina, Columbia.*

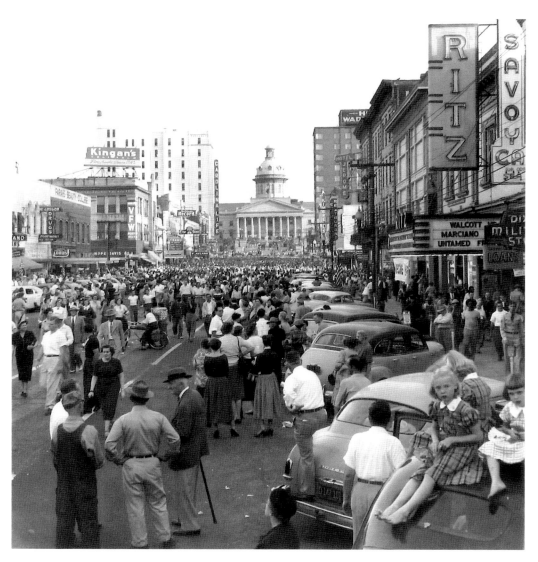

Crowd on Main Street looking toward State House, possibly September 30, 1952, when Dwight D. Eisenhower brought his presidential campaign to Columbia and spoke from the steps of the State House. On the right are the Savoy Café, Ritz Theatre and Wade Hampton Hotel. The VFW and Carolina Life buildings are on the left. *Photograph by Mum & Teal (Samuel Latimer Papers, 22-970). Courtesy of South Caroliniana Library, University of South Carolina, Columbia.*

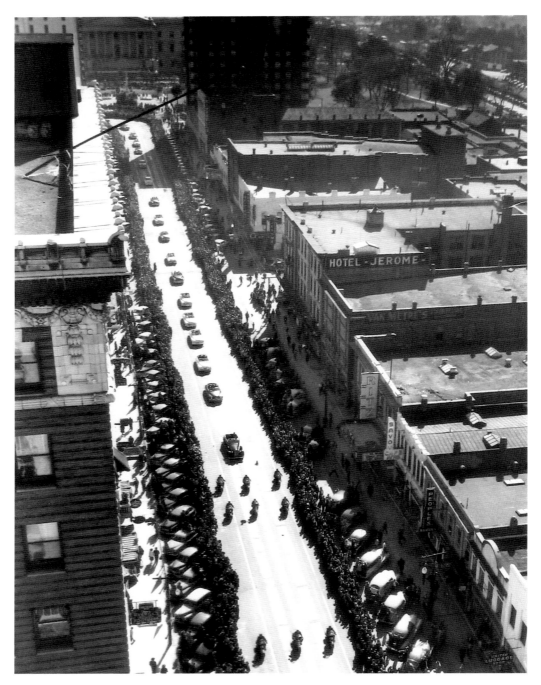

Motorcade on Main Street looking south from the top of the Palmetto Building, possibly on September 30, 1952. Dwight D. Eisenhower and James F. Byrnes rode down Main Street in an open car. The Barringer Building stands on the left, and the Hotel Jerome on the right. *Photograph by B.L. McGraw (Samuel Latimer Papers, 22-970). Courtesy of South Caroliniana Library, University of South Carolina, Columbia.*

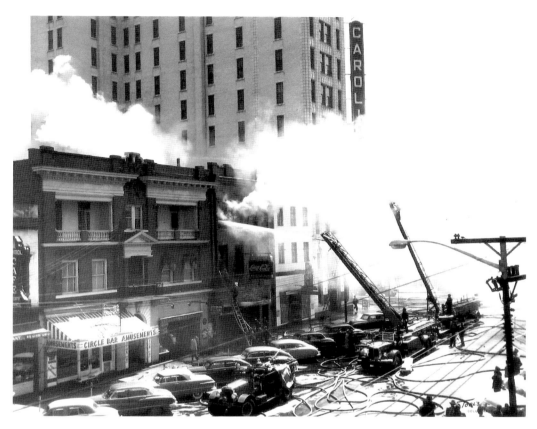

Central Drug fire, from the top of the Carolina Theatre by Toal's Studio, 1953. In the early twentieth century, on the site of the Central Drug, Sol Clark operated the Dreamland Theatre, a venue for movies and vaudeville. *(Samuel Latimer Papers, 22-970) Courtesy of South Caroliniana Library, University of South Carolina, Columbia.*

Consolidated Building, 1328 North Main Street. J. Carroll Johnson designed this building, erected circa 1912, for the Consolidated Holding Company. At one time, W.B. Smith Whaley, the architect who designed the Sylvan Building, had his office on the second floor. Today the Consolidated Building is home to Bank Meridian. *HABS SC,40-COLU,15-1. Courtesy of Library of Congress.*

THE ASSEMBLY STREET FARMERS' MARKET

The market, as did other Columbia businesses, began on Richardson (Main) Street. By 1850, it occupied the bottom level of the 1818 city hall, on the corner of Main and Washington Streets. The market bell announced the opening and closing of the market. Butchers from Butcher Town, beyond Cotton Town, brought their wares daily to the market. According to J.F. Williams, when the market closed at 9:00 a.m., the butchers then peddled their wares through the streets of Columbia.

By 1860, the market began moving west to Assembly Street. Assembly was broader than Richardson and offered better access for customers and more booth space for vendors. There, with changes, the market stayed until 1951, when it moved to Bluff Road.

During the Civil War, according to E.F. Williams, a Confederate soldier whose family had been evicted while he was in service deserted, returned to Columbia and ambushed the landlord when he pulled up to the market on his wagon.

In addition to sales at the market, farmers also peddled their wares. Williams also recounted the story of a man from Western North Carolina who arrived in Columbia in 1866 with ducks for sale. His one-horse wagon was loaded with ducks, and he had stopped in Chester and Winnsboro en route to Columbia. The Columbia market was an outlet for produce and livestock from Western North Carolina.

After the Civil War, a new market shed appeared on Assembly. It was razed in 1915 and another was erected in 1924. During the twenties, the market contributed to the growth of Columbia's red-light district on Park Street.

The market benefited from the New Deal programs of President Franklin Roosevelt and grew to include ten blocks of Assembly Street. During the 1930s, Public Works Administration funds built larger and more elaborate sheds on Assembly. Columbia grew as a regional market for Southern produce, especially watermelons, sweet potatoes, corn and beans. However, in addition to the sheds, despite city efforts, individuals continued to erect temporary booths and sell produce directly from their wagons and, later, trucks. While Columbia residents delighted in the fresh fruits and vegetables, most of the produce left Columbia by rail for eastern markets.

By 1950, Columbia merchants agitated for the market's removal. Many considered it unhygienic. The farmers and shippers who used the market also had concerns. The old market lacked refrigeration and its location in the center of Assembly Street created traffic congestion. In the early 1950s, the Assembly Street Market moved and reopened

as the South Carolina Farmers' Market on Bluff Road. The new market, operated by the South Carolina Department of Agriculture, had advantages for farmers and distributors, but with the move, Columbia was no longer the market center of South Carolina.

Drawing of the first market and city hall, northwest corner of Richardson (Main) and Washington Streets. Columbia's first city hall dated from 1818. The Columbia State Farmers' Market, also known as the Assembly Street Market, began as a small public market on the ground floor of Columbia's first city hall on Richardson (Main) Street. The clock and fire bell were in the tower that extended over the sidewalk. William Gilmore Simms wrote that the market hall clock struck one o'clock even while it burned in February 1865. *(photograph 2330.20) From a copy, courtesy of South Caroliniana Library, University of South Carolina, Columbia.*

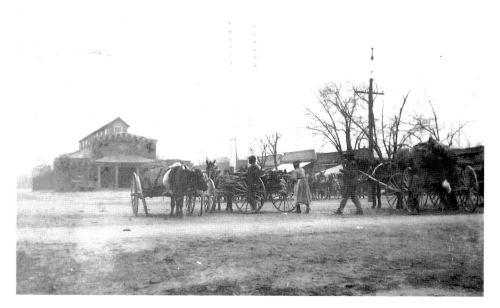

African Americans with ox and mule carts, Assembly Street Market, circa 1899. The market building on the left was built after the Civil War and razed in 1913. *Photograph by Harry M. King (photograph 12050.33). Courtesy of South Caroliniana Library, University of South Carolina, Columbia.*

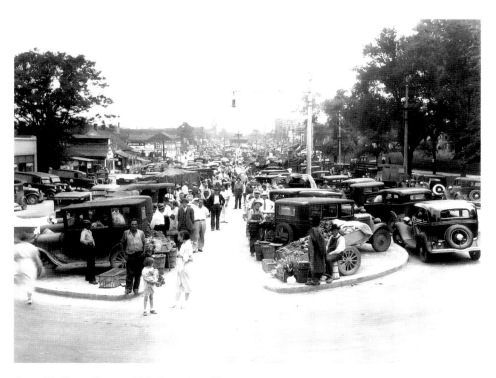

Assembly Street Farmers' Market, 1934. The Assembly Street curb market was ten blocks long and occupied the center of Assembly for about eighty-six years. In 1951, the market moved to Bluff Road. *Sargeant Studio (photograph 2330.1). Courtesy of South Caroliniana Library, University of South Carolina, Columbia.*

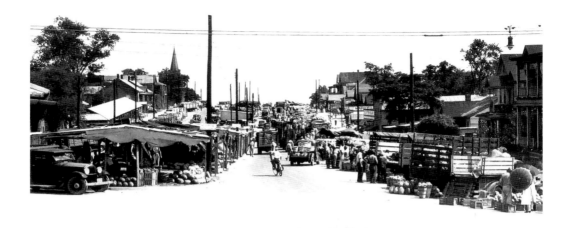

Assembly Street Market looking south to Greene Street, 1946. By 1860, at least part of the farmers' market had moved from city hall on Richardson (Main) Street to the center of Assembly Street. In 1951, the market moved from Assembly to Bluff Road. *Sargeant Studio (photograph 2330.2). Courtesy of South Carolina Library, University of South Carolina, Columbia.*

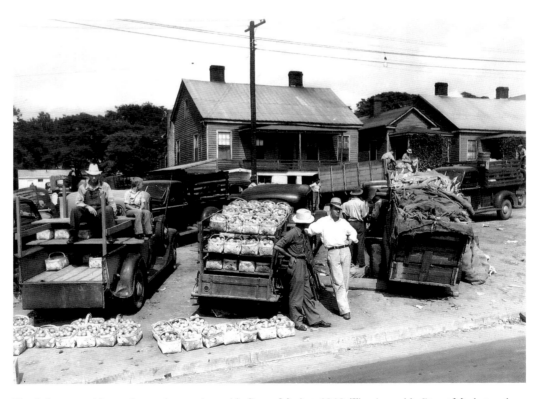

Truck farmers with peaches and corn, Assembly Street Market, 1946. The Assembly Street Market and its successor, the Columbia State Farmers' Market, provide farmers with direct access to customers and provide consumers with direct access to local produce. *Sargeant Studio (photograph 2330.4). Courtesy of South Caroliniana Library, University of South Carolina, Columbia.*

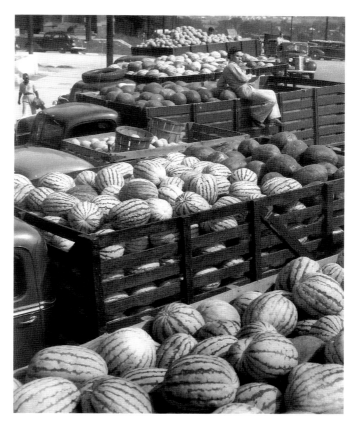

Right: Truck farmers with watermelons, Assembly Street, 1946. Pageland, South Carolina, may be famous for its watermelon festival, but thanks to the farmers' market, Columbia residents can also enjoy the summer's bounty. *Sargeant Studio (photograph 2330.5). Courtesy of South Caroliniana Library, University of South Carolina, Columbia.*

Below: Market sheds on Assembly Street, 1935. The Public Works Administration (a New Deal program established in the late 1930s) built these sheds for the Assembly Street Market. They replaced an earlier 1924 shed located north of them on Assembly. *Sargeant Studio (photograph 2330.19). Courtesy of South Caroliniana Library, University of South Carolina, Columbia.*

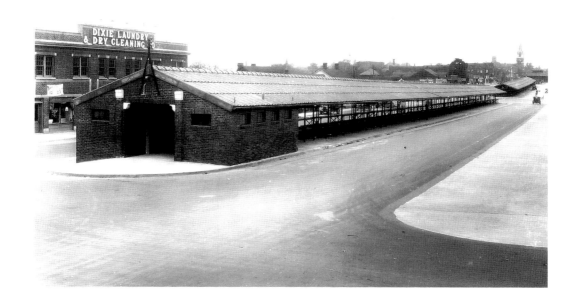

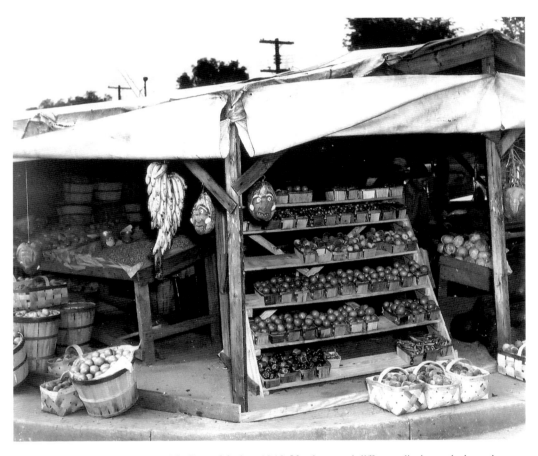

Homemade display cases, Assembly Street Market, 1946. Vendors used different display techniques in their quest for customers. Note the decorated coconuts and bunches of bananas. A deadly explosion in a gas curing tank for bananas was one reason for the market relocation. *Sargeant Studio (photograph 2330.11). Courtesy of South Caroliniana Library, University of South Carolina, Columbia.*

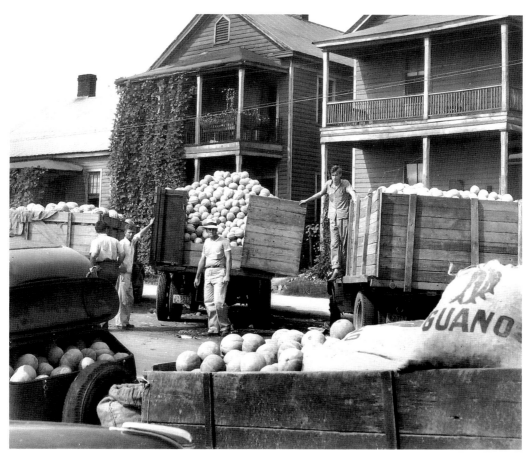

Truck farmers with cantaloupes, Assembly Street Market, 1946. Summer is the season for locally grown watermelons and cantaloupes. *Sargeant Studio (photograph 2330.9). Courtesy of South Caroliniana Library, University of South Carolina, Columbia.*

Memorial drinking fountain, Assembly and Taylor Streets, 1930s. The fountain, erected in 1925 by Mrs. A.D. Porcher, had troughs on one side for dogs and on the other side for horses. The fountain honored Mrs. Porcher's dogs, Fan and Dick. *(photograph WPA-PL-C-V-1) Courtesy of South Caroliniana Library, University of South Carolina, Columbia.*

Chapter 5
LOST NEIGHBORHOODS

When President George Washington visited in 1791, Columbia only had a few frame houses. By 1805, visitor André Michaux found well-built wooden houses generally painted yellow and gray. When Lafayette came in 1824, Columbia had five hundred houses, some of them "handsome."

As Columbia developed, a popular style of architecture was the "Columbia cottage." This style featured a raised Greek Revival cottage with an enclosed basement. Mary Boykin Chesnut entertained Confederate President Jefferson Davis at the Chesnut Cottage on Hampton Street.

After the Civil War, several of Columbia's fine antebellum houses found other uses. The Hampton Preston House, for example, housed the Ursuline Convent (1887–90), the College for Women (1890–1915) and Chicora College (1915–30).

Despite the devastation of the fire of 1865, most downtown residential districts survived Sherman's visit. Unfortunately, they could not survive changing times and a mobile workforce. By the 1950s, the imposing homes on quiet tree-lined streets were gone—victims of urban blight, commercial development and demolition. As late as the 1940s, the 2500 and 2600 blocks of Main Street were residential. Columbia lost both the Kinard, one of the oldest houses in Columbia, and the Lafayette House in the forties.

Urban renewal earned mixed reviews. Neighborhoods disappeared and new ones were created. For example, by the 1980s, areas, such as Wheeler Hill, near the University, went from poor to fashionable.

According to historian Walter Edgar, Mabel Payne, preservation officer for the city of Columbia, saved the Robert Mills House with a shotgun. The Robert Mills House was slated for demolition, but Payne kept the wrecking crew at bay until Historic Foundation members arrived with the money. Without such heroism, Columbia would have lost an architectural gem. Other houses were not as fortunate. For example, state and university offices and parking lots have replaced blocks of elegant homes on Senate, Pendleton and other Columbia streets.

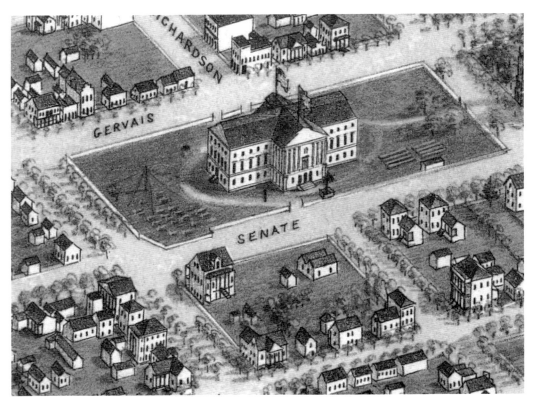

Detail of the State House and bird's-eye view of the city of Columbia, 1872. This perspective of the city displays the rural nature of downtown Columbia in the 1870s, with greenswards and few structures per city block. The rural feel of much of residential Columbia persisted into the twentieth century. As late as 1912, Edwin H. Cooper considered what is now Green Street a "wild area." *Drawn and published by C. Drie. Courtesy of Library of Congress.*

View of Columbia from the capitol, southwest. Olympia and Granby Mills are faintly visible in the distance and each house has its necessary or outhouse in the backyard. Art Work Scenes in South Carolina, *1895. Courtesy of South Caroliniana Library, University of South Carolina, Columbia.*

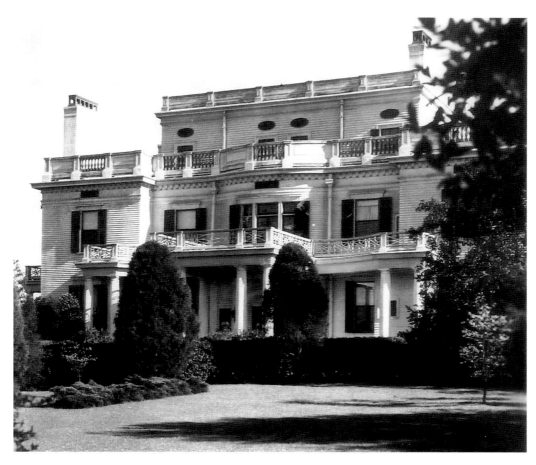

Laurel Hill, 1930s. Located on the northwest corner of Laurel and Assembly Streets, Edwin Wales Robertson (1863–1928) purchased the site known as Haskell Hill from Judge A.C. Haskell. Haskell Hill overlooked Sidney Park and had been the site of Governor John Taylor's home. Robertson was president of the Canal Dime Bank and by 1902 had erected a "large and handsome residence" there. He was later president of the National Loan and Exchange Bank; the Parr Shoals Development Company; the Columbia Railway, Gas and Electric Company; and the Record Publishing Company. In the 1930s, a brick wall surrounded the house and its garden, which reportedly included a cork oak grown from seed acquired from the Royal Botanical Gardens in London. *(photograph WPA-PL-C-H-2) Courtesy of South Caroliniana Library, University of South Carolina, Columbia.*

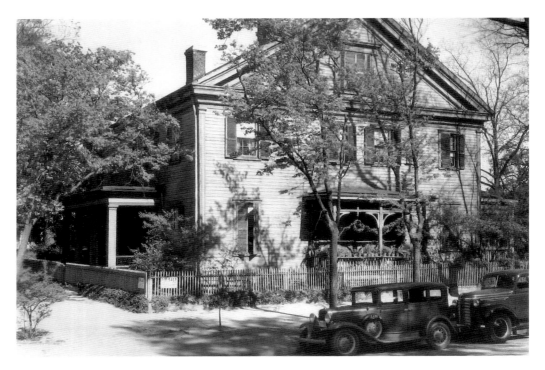

Kinard House, 1400 Lady Street, 1930s. Major John Niernsee (1814–1885), architect of the State House, bought this house, one of the oldest in Columbia, in 1858 and lived there until 1874. The Vienna-born Niernsee began construction of the present State House in 1851, but the Civil War interrupted construction. The Kinard house was demolished in 1945. *(photograph WPA-PL-C-H-8) Courtesy of South Caroliniana Library, University of South Carolina, Columbia.*

Residence of James L. Mimnaugh, Gervais Street, ward 1, 1905. In 1900, the Irish-born Mimnaugh was a twenty-seven-year-old dry goods merchant in Newberry, South Carolina. By 1897, he had a department store on the corner of Main and Hampton in Columbia. In 1921, Mimnaugh remodeled his three-story emporium and added a mail-order department. According to John Hammond Moore, by 1921, Mimnaugh's department store was selling aluminum tags for automobiles that read, "Columbia—the City Unlimited." Art Work of Columbia, *part 3. Courtesy of South Caroliniana Library, University of South Carolina, Columbia.*

Residence of Frederick H. Hyatt, Blanding Street, ward 2, 1905. Born in North Carolina, in 1900 Hyatt was manager of the South Carolina agency of Mutual Life of New York insurance company. He lived in the Eau Claire section of Columbia and was an active member of Washington Street Methodist Church. His home exemplified comfortable suburban living. Note the fountain in the yard. Art Work of Columbia, *part 4. Courtesy of South Caroliniana Library, University of South Carolina, Columbia.*

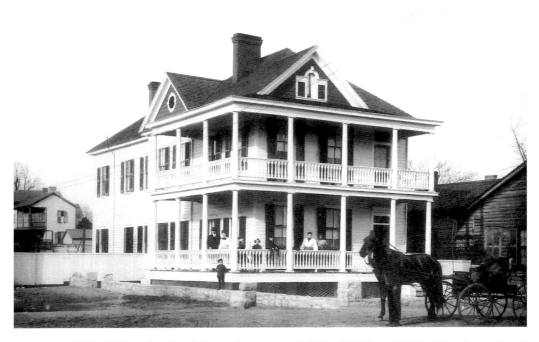

Residence of John William Strickland, Taylor Street, ward 3, 1905. J. William "Bill" Strickland, a native of Columbia, operated a livery and sale stable in the 1300 block of Taylor Street. Strickland also served two terms as a city councilman from ward 3. In 1912, he relocated to Richmond, Virginia, where he died in 1922. *Art Work of Columbia, part 8. Courtesy of South Caroliniana Library, University of South Carolina, Columbia.*

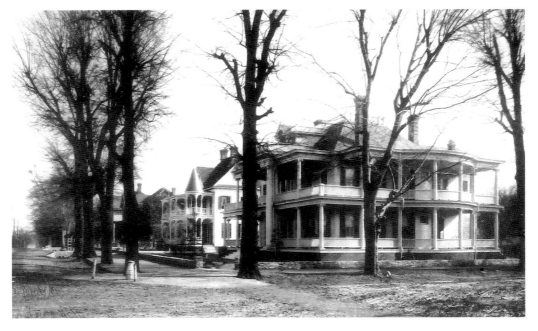

Scene on Gervais Street, 1905. This scene captures the beautiful homes found in Columbia's downtown residential neighborhoods at the turn of the century. *Art Work of Columbia, part 1. Courtesy of South Caroliniana Library, University of South Carolina, Columbia.*

View on Marion Street, 1905. In 1892, John Andrews Rice noted that in Columbia there are "trees everywhere." Art Work of Columbia, *part 9. Courtesy of South Caroliniana Library, University of South Carolina, Columbia.*

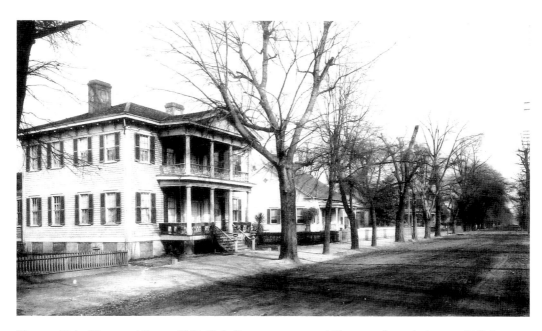

View on Plain (Hampton) Street, 1905. Plain Street was renamed Hampton Street in honor of Wade Hampton. Columbia-style cottages coexisted with grander houses. Art Work of Columbia, *part 9. Courtesy of South Caroliniana Library, University of South Carolina, Columbia.*

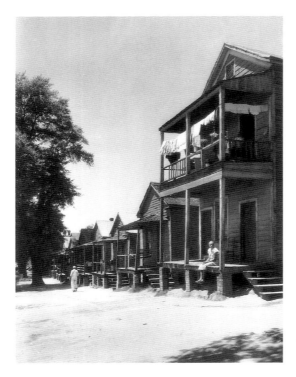

Left: African American housing, 1930s. Columbia in the 1930s was a city of contrasts and a city coping with the Great Depression. While many white residents lived in tree-lined neighborhoods, many African American neighborhoods presented a different image. All Columbians, however, faced economic uncertainties. W. Lincoln Highton, the photographer of this image, was the chief photographer for the United States Information Service in the late 1930s. His photographs captured daily life and work in the thirties. *(photograph WPA-PL-C-H-22) Courtesy of South Caroliniana Library, University of South Carolina, Columbia.*

Below: Outhouses, 1952. Poverty and segregation made life difficult for many Columbia residents. In the 1950s and later, some areas around Columbia lacked running water and paved streets. *Manning Harris, photographer (photograph M-PL.C.H.22). Courtesy of South Caroliniana Library, University of South Carolina, Columbia.*

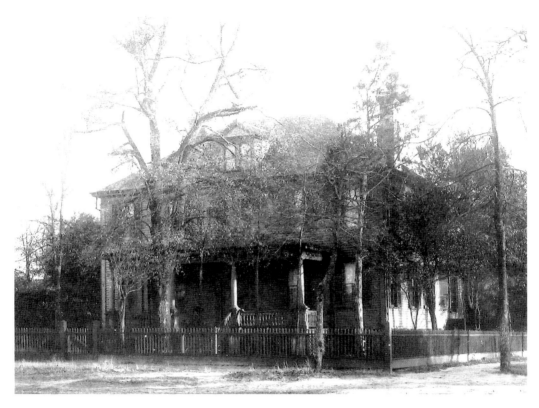

House in which General Wade Hampton died, 1800 Senate Street, 1905. Born in 1818, Hampton was a lieutenant general, CSA, during the Civil War, and served as governor of South Carolina from 1876 to 1879 and in the United States Senate. Hampton died here on April 11, 1902. Art Work of Columbia, *part 7. Courtesy of South Caroliniana Library, University of South Carolina, Columbia.*

Lost or Changed Institutions

Through the years, many educational, religious and governmental institutions have come and gone. There are a number of reasons for this shifting parade—new styles of architecture, improved resources, financial considerations, fire, transportation and market changes.

Columbia is and has been home to many educational enterprises. During the antebellum period, it was mecca for male and female education. Nevertheless, the most important for the development of the city was South Carolina College, chartered in 1801.

After his inauguration in 1876, one of Governor Wade Hampton's first actions was the closing of the University of South Carolina. The university had integrated during Reconstruction. When the school reopened in 1880, it was known as the South Carolina College of Agriculture and Mechanic Arts. Gone were the days when William C. Preston (president of South Carolina College, 1846–51) could write, "The College is sustained by legislative patronage exclusively, but in so liberal a way that the trustees have never asked an appropriation which has not been promptly made." The South Carolina legislature offered the newly opened college little funding. The school depended primarily on federal funds secured through the Morrill Land Grant College Act.

As early as the 1790s, Columbia had Male and Female Academies. The Female Academy stood on the corner of Washington and Marion Streets. Columbia High School is a direct descendant of the old Female Academy. The Male Academy stood on the block formed by Laurel, Richland, Pickens and Henderson Streets. It, too, became part of the city school district, but closed in 1964.

In 1828, the Presbyterian Synod of South Carolina and Georgia founded Columbia Theological Seminary in Georgia. In 1831, the seminary moved to Columbia and occupied the Robert Mills House until its 1925 move to Decatur, Georgia. In 1886, Winthrop Training School, the forerunner of Winthrop University, opened in the former chapel of the seminary.

The South Carolina Collegiate Female Institute, founded by Dr. Elias Marks, operated at Barhamville from 1828 to 1865. Its more famous students included John C. Calhoun's daughter, Anna Maria, and the savior of Mount Vernon, Ann Pamela Cunningham.

The South Carolina Conference of the Methodist Episcopal Church purchased land on Hampton Street, between Pickens and Henderson Streets, in 1854. This land became the site of Columbia Female College. Chartered by the legislature in 1854, the

school closed in 1865, but reopened in 1873. In 1905, Columbia College relocated to North Columbia.

In 1881, Bishop W.F. Dickerson of the African Methodist Episcopal Church moved Payne Institute from Cokesbury to Columbia. In Columbia, the institute became Allen University and educated many of Columbia's African American leaders.

The South Carolina Presbyterian Institute, founded in 1886, became the South Carolina College for Women in 1910. Eventually, the school, which operated for many years in the Hampton Preston House, merged first with Chicora College and later with Queens College in Charlotte, North Carolina.

In addition to educational institutions, Columbia has seen many changes in religious institutions, public healthcare, penal reform, libraries and public office buildings. Columbia was the site of groundbreaking advances in the care of the mentally ill and in penology. Citizen involvement produced two of its largest hospitals, and fire and fashion created a moveable feast of city halls and courthouses. By 1907, the South Carolina State House was finally complete.

Despite the changes, Columbia continues to be a center for higher education, state and county government and quality healthcare.

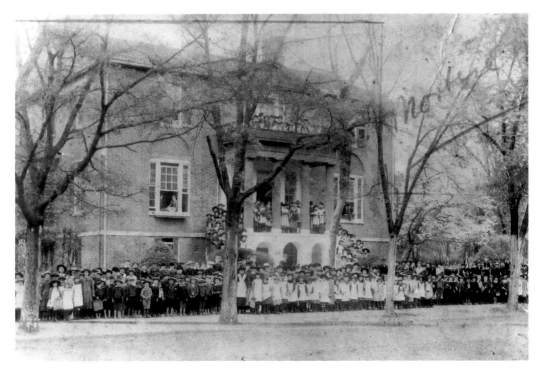

Columbia Female Academy, Washington and Marion Streets, circa 1880. The school became coeducational in 1880 before control passed to the Richland School District. In 1915, the district laid the cornerstone for a new Columbia High School on this site. At present, First Baptist Church's Family Life Center occupies this location, and since December 1975, Columbia High School has been located in St. Andrews. *(photograph M-PL-C-S-5) From a copy, courtesy of South Caroliniana Library, University of South Carolina, Columbia.*

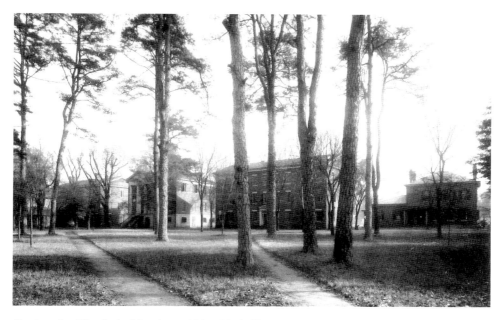

Presbyterian Theological Seminary, 1905. Ainsly Hall, the Mills House, stands in the center of the seminary buildings. Founded in Georgia in 1828, the seminary moved to Columbia in 1830 and then in the 1920s Columbia Theological Seminary moved to Decatur, Georgia. *Art Work of Columbia, part 5. Courtesy of South Caroliniana Library, University of South Carolina, Columbia.*

Columbia Bible College, Ainsley Hall/Robert Mills House, 1616 Blanding Street, 1952. Columbia Bible School opened in 1923 with seven students meeting in rented space at the Colonia Hotel. Robert C. McQuilken was the institution's first president. In 1929, the school became Columbia Bible College and later Columbia International University. In 1960, the college moved to its present campus off Monticello Road. *Photograph by Barclay Jones (photograph M-Pl-C-CS-3). Courtesy of South Caroliniana Library, University of South Carolina, Columbia.*

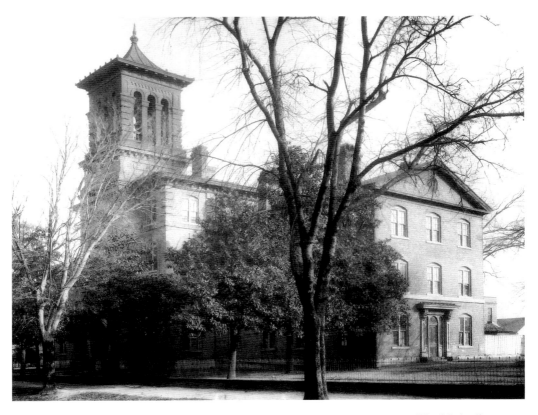

Columbia Female College, Hampton Street between Pickens and Henderson, 1905. The Methodist Annual Conference founded Columbia Female College in 1854. The college opened on Plain (Hampton) Street, two blocks east of Washington Street Methodist Church. Whitefoord Smith, a former pastor of Washington Street, was the school's first president. According to A.V. Huff, "Every Sunday while the college was in session, the students of Columbia Female College attended the church in a body." Following the Civil War, this building housed Nickerson's Hotel, the college at times, the Colonia Hotel and the Columbia Bible College. Art Work of Columbia, *part 3. Courtesy of South Caroliniana Library, University of South Carolina, Columbia.*

Grounds of the Presbyterian College for Women, 1905. Begun in 1886, the South Carolina Presbyterian Institute opened October 1, 1890, in the Hampton-Preston House, famed for its formal gardens. In 1910, the name was changed to the Presbyterian College for Women. In 1914, the college merged with Chicora College in Greenville. The new Chicora College then operated in Columbia from 1915 to 1930. Due to the onset of the Great Depression, Chicora College left Columbia in 1930 and merged with Queens College in Charlotte. Art Work of Columbia, *part 4. Courtesy of South Caroliniana Library, University of South Carolina, Columbia.*

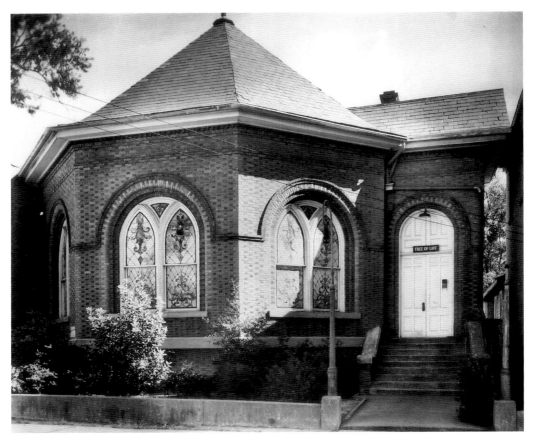

Tree of Life Synagogue, 1320 Lady Street. In May 1904, the cornerstone for Tree of Life Synagogue, designed by J.H. Sams and Avery Carter, was laid with Masonic ceremonies. The Reformed congregation celebrated the dedication of the building in September 1905. The Tree of Life Synagogue is located on North Trenholm Road. *Photograph by Henry Cauthern (photograph M-PL-C-C-3). Courtesy of South Caroliniana Library, University of South Carolina, Columbia.*

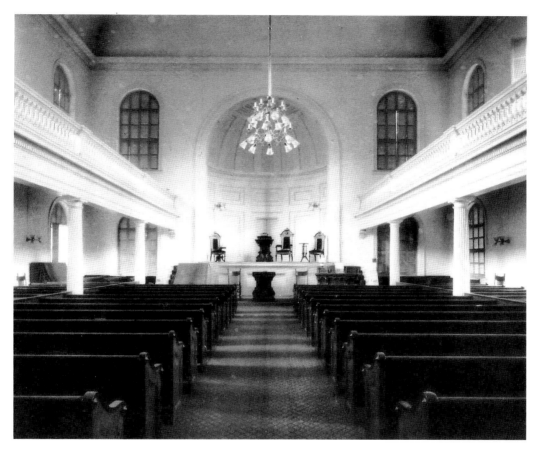

Interior of the First Baptist Church, 1905. This Baptist congregation organized in 1809 and in 1811 built its first sanctuary on the corner of Sumter and Hampton Streets. This building, the site of the first meeting of the Secession Convention on December 17, 1860, was built in 1859. The 1811 building burned in February 1865. During the Civil War, the First Baptist Church was the largest church in Columbia. Art Work of Columbia, *part 8. Courtesy of South Caroliniana Library, University of South Carolina, Columbia.*

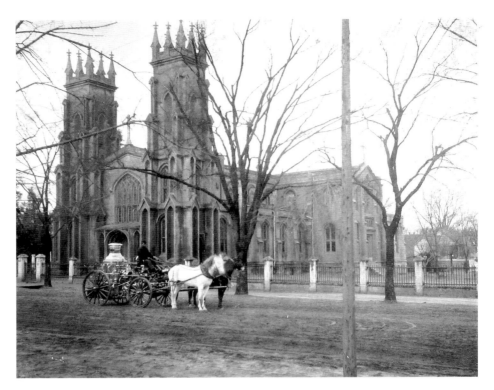

Trinity Cathedral, Sumter and Senate Streets, circa 1899. The South Carolina General Assembly incorporated Trinity Cathedral in 1813 as the Episcopal Church of Columbia. In 1812, Reverend Mr. Andrew Fowler conducted the first known Episcopal service in Columbia in the old State House. A number of prominent South Carolinians, including General Wade Hampton, are buried in the Trinity churchyard. A horse-drawn fire engine uncharacteristically pauses before the church. *Photograph by Harry M. King (photograph 12050.31). Courtesy of South Caroliniana Library, University of South Carolina, Columbia.*

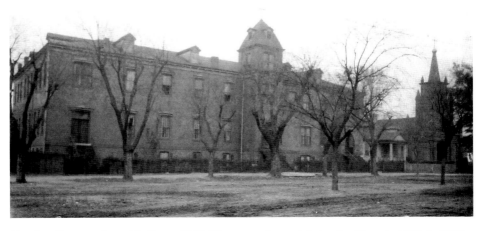

Ursuline Convent, Assembly Street, 1905. The nuns relocated their school here in 1890. In 1892, the Ursuline parochial school and academy had 125 students. The nuns established the academy "for the education of little girls and young ladies…with particular attention paid to music and art." Art Work of Columbia, *part 4. Courtesy of South Caroliniana, University of South Carolina, Columbia.*

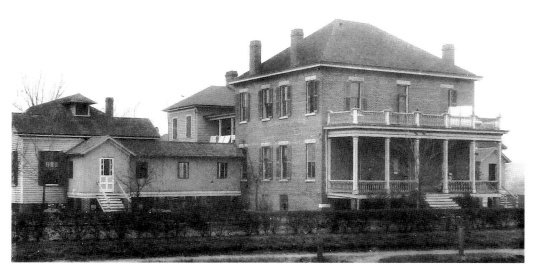

Columbia Hospital, 1905. Columbia Hospital opened at Hampton and Harden Streets in 1895. In 1921, Richland County became responsible for the hospital, and in 1972 Richland Memorial Hospital (Palmetto Richland) replaced Richland County Hospital. Art Work of Columbia, *part 5. Courtesy of South Caroliniana Library, University of South Carolina, Columbia.*

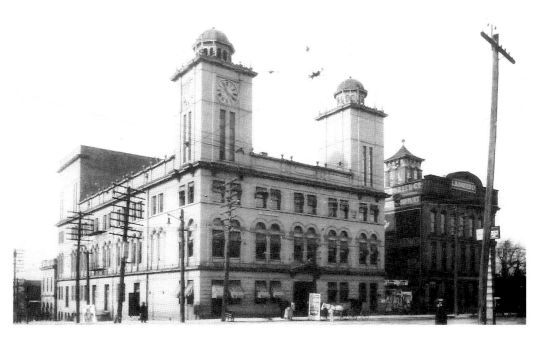

City hall and opera house, Main and Gervais Streets, 1905. Columbia City Hall and Columbia Theatre (popularly known as the opera house) opened December 1, 1900. The tower on the left contained the town clock. L.B. Dozier & Co., plumber and mill supplies, occupied the adjacent building. Art Work of Columbia, *part 5. Courtesy of South Caroliniana Library, University of South Carolina, Columbia.*

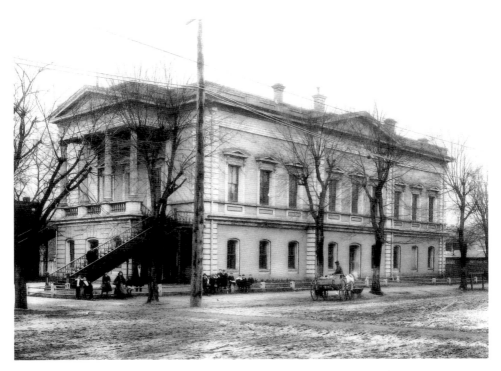

Richland County Courthouse, Washington and Sumter Streets, 1905. Richland County's fourth courthouse was built in 1872 and razed in 1935. Art Work of Columbia, *part 4. Courtesy of South Caroliniana Library, University of South Carolina, Columbia.*

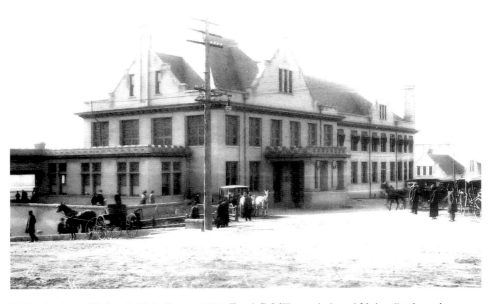

Union Station, 401 South Main Street, 1905. Frank P. Milburn designed Union Station, also known as Atlantic Coast Line and Southern Railway Station. Prior to its construction, Columbia had two rail stations and as Columbia's economy grew, so did the need for one central station. Union Station opened January 14, 1902. Art Work of Columbia, *part 6. Courtesy of South Caroliniana Library, University of South Carolina, Columbia.*

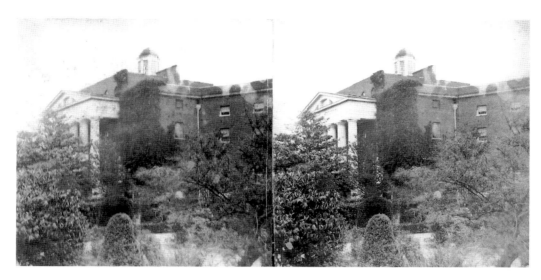

State Hospital (Female), 1870s. When built in 1828, the Robert Mills–designed State Hospital offered an innovative approach to the treatment of mental illness. At the time of this photograph, the original building housed female patients. *Stereograph by W.A. Reckling (photograph 12276.3). Courtesy of South Caroliniana Library, University of South Carolina, Columbia.*

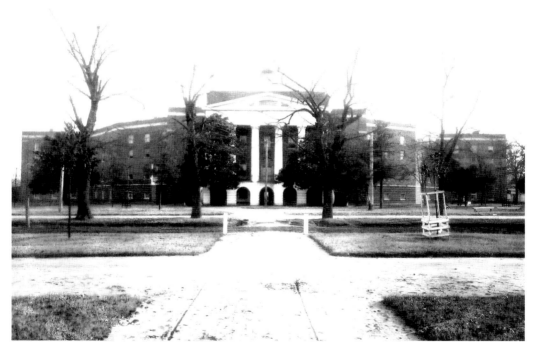

State Hospital Mills Building, 1905. Completed in 1828, Robert Mills designed this facility to provide humane treatment for South Carolina's mentally ill. Art Work of Columbia, *part 9. Courtesy of South Caroliniana Library, University of South Carolina, Columbia.*

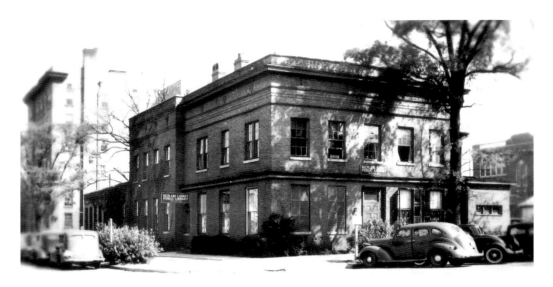

Richland County Public Library, northeast corner of Washington and Sumter Streets, 1930s. Libraries in Columbia have a long history, but most of the early ones were subscription libraries that charged fees. The roots of today's Richland County Library system lie in the Columbia Library Association, chartered in 1896. Originally, the library operated from a room in city hall. After a number of moves, in 1929 the library moved to this site and occupied the first floor of the home of Dr. James Woodrow, uncle of President Woodrow Wilson. In 1939, the library purchased the Woodrow House. *(photograph WPA-PL-C-V-2) Courtesy of South Caroliniana Library, University of South Carolina, Columbia.*

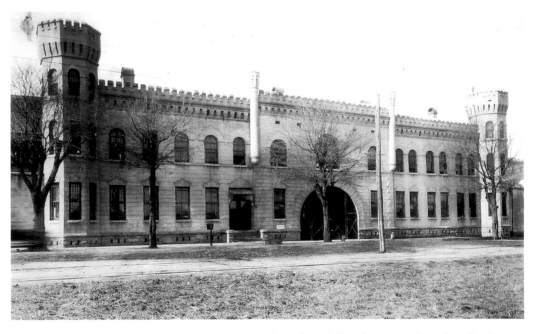

South Carolina State Penitentiary, 1910s. Located on the Columbia Canal, construction of the South Carolina State Penitentiary began in 1866. Substantially complete in the 1880s, in 1882 the penitentiary housed 956 prisoners, including 41 women. The old penitentiary (later Central Correction Institution) is gone and the site is under redevelopment. *(photograph 11622.10) Courtesy of South Caroliniana Library, University of South Carolina, Columbia.*

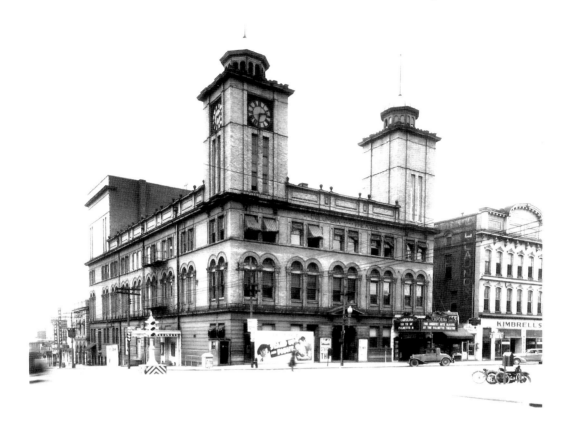

Above: Palmetto Theatre (the former Columbia City Hall), circa 1939. The marquee reads, "Carolina. The best acts always at the Palmetto Theatre." The billboard advertises *Stand Up and Fight*. MGM made *Stand Up and Fight* in 1939. The movie, directed by W.S. Van Dyke, starred Wallace Beery and Robert Taylor. Kimbrell Furniture Store is on the right. *(photograph 6752.1) Courtesy of South Caroliniana Library, University of South Carolina, Columbia.*

Right: First Town Theatre, reconstructed from the R.B. Sloan house on Sumter Street. Town Theatre, 1012 Sumter Street, is one of the oldest community theatres in the United States. The theatre began in 1919 as the Columbia Stage Society under the direction of Daniel A. Reed. By its second season, the troupe had acquired and remodeled this house for its performances. In 1924, Town Theatre got a new building. *(photograph M-PL-C-Th-2) Courtesy of South Caroliniana Library, University of South Carolina, Columbia.*

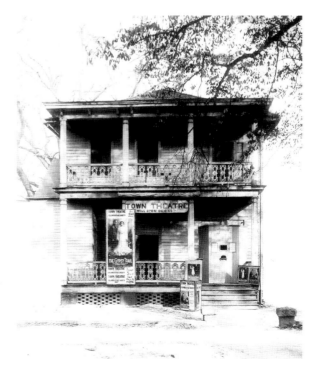

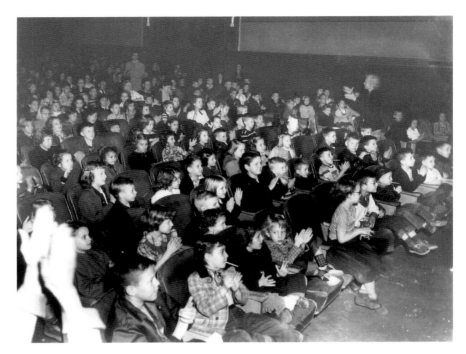

Story time, Five Points Theatre, Harden Street, circa 1940s. Five Points, named for its location at the intersection of Harden Street, Devine Street and Santee Avenue, was Columbia's first suburban commercial district with shopping and restaurants. *(photograph 10352.33) Courtesy of South Caroliniana Library, University of South Carolina, Columbia.*

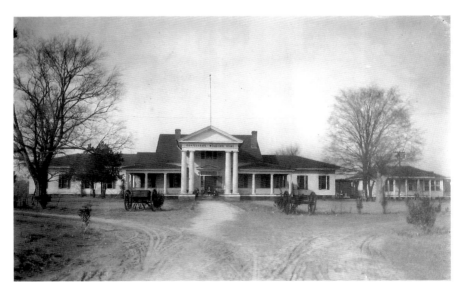

Confederate Soldiers' Home, Confederate Avenue at Bull Street, 1910s. Established by the South Carolina General Assembly in 1908 to house two needy, infirm veterans from each county, the Confederate Home and Infirmary in Columbia opened its doors on May 10, 1909. Beginning in 1925, the home also accepted wives and widows and later, daughters and nieces. Although the home closed in 1958, a small cemetery remains on the site. *(photograph 11622.3) Courtesy of South Caroliniana Library, University of South Carolina, Columbia*

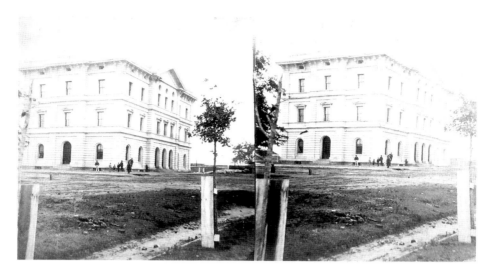

Post office, 1870s. In 1870, the English-born Alfred B. Mullett designed the courthouse and post office at the corner of Main and Laurel Streets. Since 1937, this historic building has housed city government. *Stereograph by W.A. Reckling (photograph 12276.1). Courtesy of South Caroliniana Library, University of South Carolina, Columbia.*

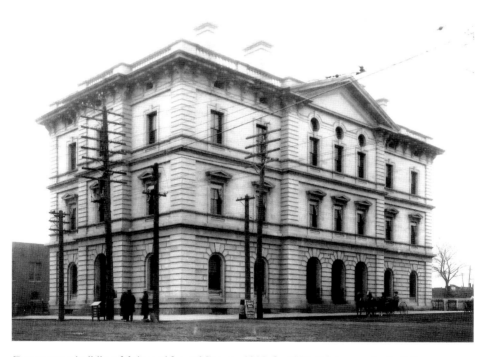

Government building, Main and Laurel Streets, 1905. In 1905, this impressive building, designed in 1870, housed the Columbia Post Office. In 1865, President Ulysses Grant appointed Alfred B. Mullett United States supervising architect. Among many other federal buildings, Mullett designed this one. In 1937, the building became Columbia City Hall. After the State House, this is the "oldest government building in Columbia." Art Work of Columbia, *part 2. Courtesy of South Caroliniana Library, University of South Carolina, Columbia.*

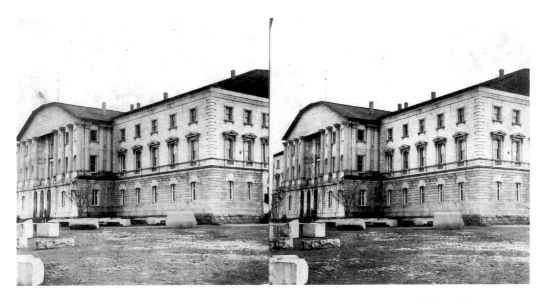

South Carolina State House, circa 1878. The State House still had its temporary roof. According to Harvey Teal, Morgan, the photographer, operated several photographic studios in North Carolina and occasionally came to South Carolina. He died in 1880. Bayard Wootten, his daughter, became a well-known photographer as well. *Stereograph by Rufus Morgan, Morganton, North Carolina (photograph 12559.1). Courtesy of South Caroliniana Library, University of South Carolina, Columbia.*

A view of the State House grounds, with Trinity Cathedral in the background, 1905. Although Niernsee's original plans called for gardens and landscaping around the State House, little work was done until the 1870s. In 1878, workers laid out walks and drives and sowed grass, and in 1883 convict labor planted trees. At one point, there was a small lake on the site. Art Work of Columbia, *part 2. Courtesy of South Caroliniana Library, University of South Carolina, Columbia.*

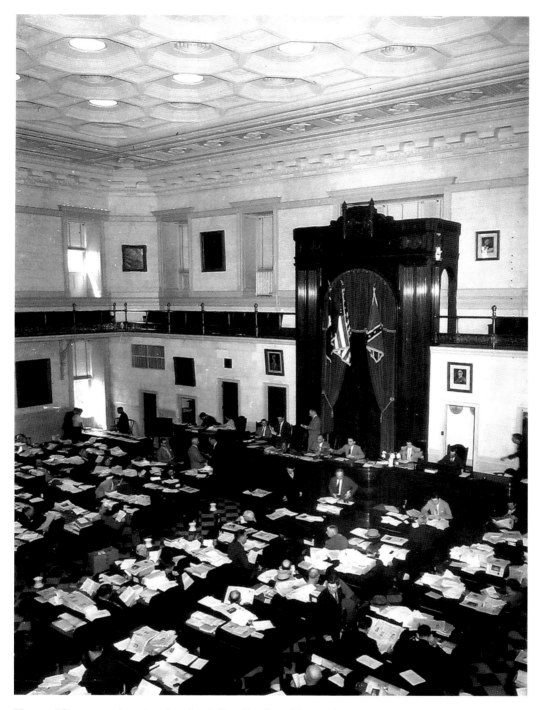

House of Representatives chamber, South Carolina State House, circa 1938. This photograph shows the hall of the House of Representatives before the 1967 wainscoting and after the mahogany rostrum was added in 1937. The 1756 gold-burnished silver mace lies on the speaker's desk, indicating that the house was in session. Since its theft in 1971, the mace resides in a special vault. *W. Lincoln Highton, photographer (photograph WPA-PL-C-SH-1). Courtesy of South Caroliniana Library, University of South Carolina, Columbia.*

EPILOGUE

Much has been lost and much has been gained. The Columbia skyline continues to change and its neighborhoods reinvent themselves. The images in this book can only suggest the Columbia of yesteryear, but memory is an important tool. Remembering gives context to the present and hope for the future. May all residents cherish and preserve the jewels that remain—the buildings that connect the present with the past.

Selected Reading List

Edgar, Walter B., and Deborah K. Woolley. *Columbia: Portrait of a City*. Norfolk, VA: Donning Company, 1986.

Hennig, Helen Kohn. *Columbia, Capital City of South Carolina 1783–1936*, with supplement by Charles Lee, 1936–66. Columbia: State Printing Co., 1966.

Lucas, Marion B. *Sherman and the Burning of Columbia*. Columbia: University of South Carolina Press, 2008.

Maxey, Russell. *Historic Columbia: Yesterday and Today in Photographs*. Columbia: R.L. Bryan Company, 1980.

Montgomery, John A. *Columbia, South Carolina: History of a City*. Woodland Hills, CA: Windsor Publications, Inc., 1979.

Moore, John Hammond. *Columbia & Richland County: A South Carolina Community, 1740–1990*. Columbia: University of South Carolina Press, 1993.

Richards, Miles. *Remembering Columbia, South Carolina: Capital City Chronicles*. Charleston: The History Press, 2006.

Sennema, David C., and Martha D. Sennema. *Columbia, South Carolina: A Postcard History*. Charleston: Arcadia Publishing, 1997.

South Caroliniana Library and Institute for Southern Studies, eds. *A Columbia Reader*. Columbia: R.L. Bryan Company, circa 1986.

Woody, Howard. *South Carolina Postcards, volume V, Richland County*. Charleston: Arcadia Publishing, 2000.

INDEX